D0834391

# FOCUS ON
## digital landscape photography

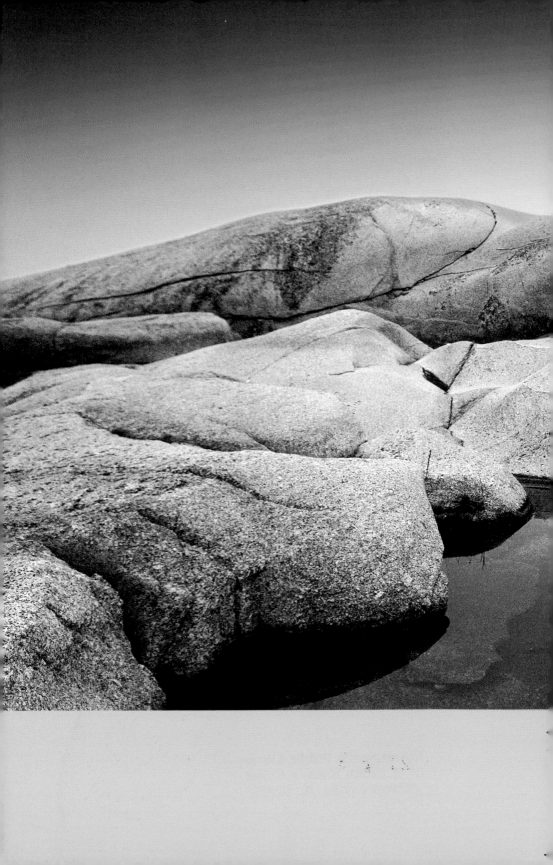

# FOCUS ON

## digital landscape photography

### George Schaub

LARK
PHOTOGRAPHY
BOOKS

A Division Of Sterling Publishing Co., Inc.
New York / London

Art Director: Tom Metcalf
Cover Designer: Thom Gaines
Production Coordinator: Lance Wille
Editor: Kevin Kopp

Library of Congress Cataloging-in-Publication Data

Schaub, George.
  Focus on digital landscape photography / author, George C. Schaub. – 1st ed.
      p. cm.
  ISBN 978-1-60059-596-7
  1. Landscape photography. 2. Photography–Digital techniques. I. Title.
  TR660.S3286 2010
  778.9'36–dc22
                              2009043786

10 9 8 7 6 5 4 3 2 1
First Edition

Published by Lark Books, A Division of
Sterling Publishing Co., Inc.
387 Park Avenue South, New York, N.Y. 10016

Distributed in Canada by Sterling Publishing,
c/o Canadian Manda Group, 165 Dufferin Street
Toronto, Ontario, Canada M6K 3H6

Distributed in the United Kingdom by GMC Distribution Services,
Castle Place, 166 High Street, Lewes, East Sussex, England BN7 1XU

Distributed in Australia by Capricorn Link (Australia) Pty Ltd.,
P.O. Box 704, Windsor, NSW 2756 Australia

If you have questions or comments about this book, please contact:
Lark Books
67 Broadway
Asheville, NC 28801
(828) 253-0467

Manufactured in China

ISBN 13: 978-1-60059-596-7

For information about custom editions, special sales, premium and corporate purchases, please contact Sterling Special Sales Department at 800-805-5489 or specialsales@sterlingpub.com. For information about desk and examination copies available to college and university professors, requests must be submitted to academic@larkbooks.com. Our complete policy can be found at www.larkbooks.com.For information about custom editions, special sales, premium and corporate purchases, please contact Sterling Special Sales Department at 800-805-5489 or specialsales@sterlingpub.com.

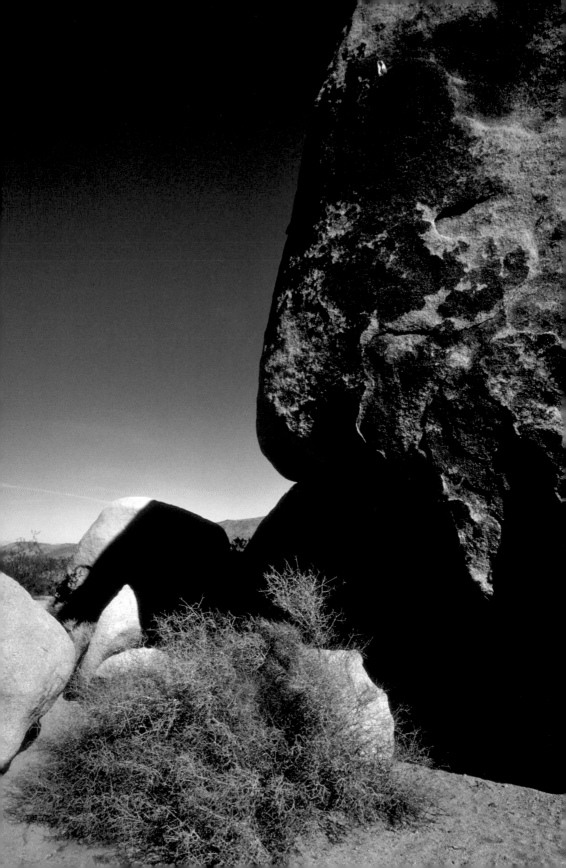

# Contents

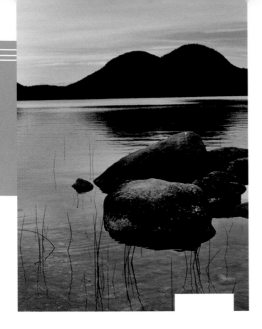

# Introduction

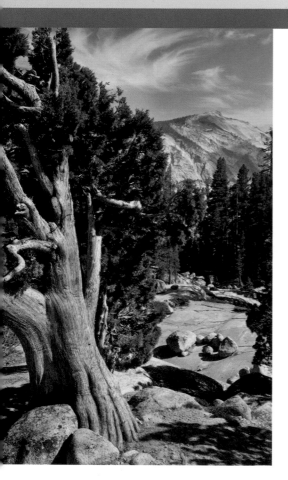

Rather than using a style like an instruction manual to routinely march through photographic functions, this how-to guide explains techniques as separate topics within the context of an application or exercise. Because a particular camera feature or function is rarely used in isolation, each topic within the book will look at ways to coordinate the proper tools with settings and techniques. Follow the processes, and you will find yourself becoming familiar with the features and functions of your camera, as well as understanding technical methods that will lead you to get the most out of your photography.

Each discrete topic is organized as follows:

- The scenario: The situation or type of shot we are going to make.

- The tools: What will help you create the photo? This can include metering mode, menu settings, aperture and shutter speed combinations, etc.

- The technique: A description of how to produce the shot along with step-by-step illustrations.

- The camera settings: How was the camera set to record the images shown?

The aim of this book is to offer tips and techniques that will help you make better photographs, ones that express what you see and that prompted you to snap the shutter in the first place. It is set up as a series of techniques that touch on many functions within your camera—from exposure and focusing modes, to menu settings for enhancing contrast, color, and even mood.

# Thinking About Your Pictures

Everyone sees a landscape scene a little differently, but there are a few basic concepts that can serve as a helpful checklist to make sure you have the foundation for capturing good photos. As you make an effort to consistently apply these ideas, you will soon discover that they become a regular part of your photographic method.

### What is the main subject or statement I am making with this photograph?

You (and your viewer) should know why you took the photo. The subject could be the way light falls in the scene, or a study of tonality, or it could be a depiction of a moment of beauty in a scene that struck your eye, like a mountain landscape, a sunset over the ocean, a tree, or a flower. But knowing what you are trying to accomplish will guide you in how you compose, expose, and focus the picture.

### How much of the scene do I want to encompass in the frame?

The focal length of the lens has a great deal to do with how much you show in the frame. In general, a telephoto lens is useful to record details and often lends itself to shooting abstract photos because it narrows your normal angle of view. A zoom lens allows you to change the angle of view, affecting the sense of place in a landscape photo, and your presence in it. A wide-angle lens can produce startling pictures by taking the image beyond the normal bounds of peripheral vision, while a super-wide angle introduces distortion that can be both unsettling and fascinating.

### What image effects will be most effective for the photo?

The two main image effects in photography are (1) the way in which motion is depicted through use of shutter speed settings, and (2) how the relation between foreground and background is portrayed through selected aperture settings—determining what's sharp and unsharp in the frame (depth of field). Using shutter speed and aperture settings in creative ways for each photo puts incredible interpretive power in your hands.

### How can I make a photograph as I see the scene rather than the way the camera might objectively document it?

There can be a difference between what you see (emotionally and physically) and what the camera might record. Knowing this gap exists, you need to understand exposure and focusing techniques, and learn when you can rely on the camera's automated functions, or when you need to assert manual control. It takes practice, experience, and a willingness to try different approaches to making pictures.

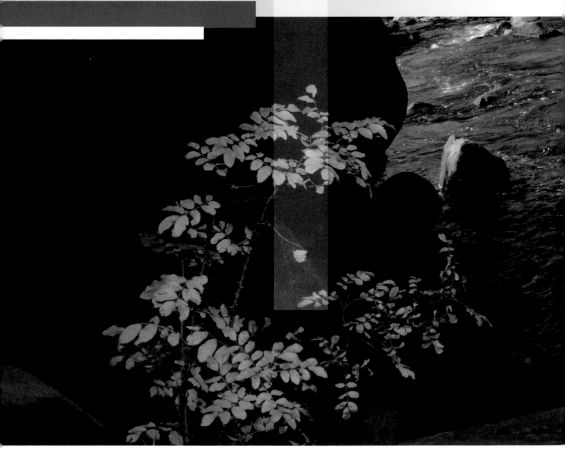

# The Adventure Begins

**Y**our decision to work with a digital camera allows you to enter a whole new world of making images. A digital image begins as an electronic signal generated by light, and ends up as binary code that describes color, brightness, and tonality. It is the way you choose to deal with these codes that makes digital photography so exciting, opening the door to the imaginative world of creating images.

Each picture holds great potential that can be revealed by how you perceive a scene in nature, expose that scene with your camera, and process the digital information. The great circle of making good photographs begins with seeing and studying light. It continues by understanding how to use the tools at your disposal to get the most from that light. Recording in RAW format is one of those tools that allows you to capture and retain the widest possible range of color, light, and visual information in each shot.  And the circle becomes complete as you edit, process, and begin to share your vision with others.

# 1.1 Realizing the Grand Potential
## of Digital Photography

## Tools:

- Live View mode
- Camera menus
- RAW conversion software
- Image processing software

**You can expect to do something** special with a landscape photo every time you survey a scene with your digital camera, no matter what lighting condition, contrast situation, or exposure challenge you may face. I am not talking about trying to fix a recorded image's problems using software; I'm talking about an approach to photography. You should be thinking about what you can do with a digital image in the final analysis, before releasing the shutter button, as you consider how to compose and expose the scene. Take a look into the future while realizing the vast quantity of raw data you will have to work with.

Appreciating the tremendous potential of the medium will make you a better photographer. This approach opens photographic possibilities and allows you to take chances,

fostering a sense of daring and experimentation that can raise the level of your photographic artistry. Once you realize what is possible, you can make new assumptions about the image.

For example, Playback mode allows you to decide immediately whether a photo is a keeper, or if you need to re-shoot it on the spot. You can also use Live View to see the effect of color balance, depth of field, or even how your photo might look as a black and white—all before you record the image. These are tools previous generations of photographers only dreamed about.

Yet, even with those tools, the image you see during initial review in the LCD is often only a pale sketch of what you can create with the captured image information. The initial exposure is only the first step towards what will be the final interpretation, because image-processing software now affords you countless more possibilities to explore.

The photo of tidal pools (right top) emulates what you might see on the camera's LCD after taking a shot and being disappointed with the result. At first glance, you might decide to delete the image. But by understanding the possibilities, you can apply digital

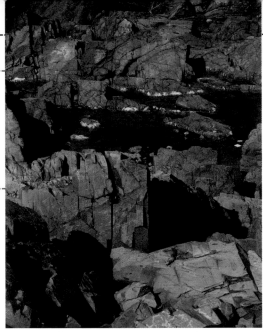

*Exposure Mode:* Aperture Priority
*Aperture:* f/8
*Shutter Speed:* 1/125 second
*ISO:* 100
*Metering:* Center-weighted Averaging
*White Balance:* Auto

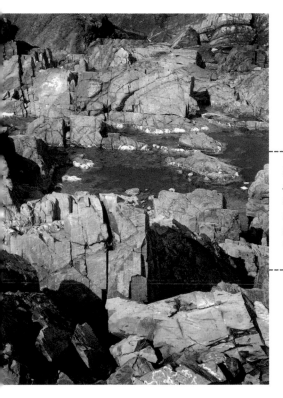

*Exposure Mode:* Aperture Priority
*Aperture:* f/8
*Shutter Speed:* 1/125 second
*ISO:* 100
*Metering:* Center-weighted Averaging
*White Balance:* Cloudy (adjusted in processing)

**did u know?**

Though it is preferable to set your camera so it records the best possible image when you press the shutter release, the immense amount of data captured within a digital file offers the potential to create an excellent photo nearly every time you shoot an image, given that you follow some basic rules of exposure, focusing, and keeping the camera steady during exposure.

adjustments to boost the light and color so it looks like the scene that caused you to take the picture in the first place. Even if the first look isn't what you envisioned, processing the image will liberate its true beauty. The point is to realize this potential and learn how to bring it forth (above).

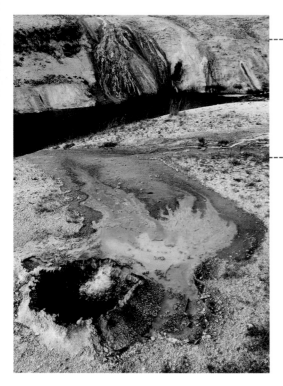

*Exposure Mode:* Aperture Priority
*Aperture:* f/8.0
*Shutter Speed:* 1/100 second
*ISO:* 100
*Metering:* Multi-segment (Evaluative/Pattern)
*White Balance:* Auto

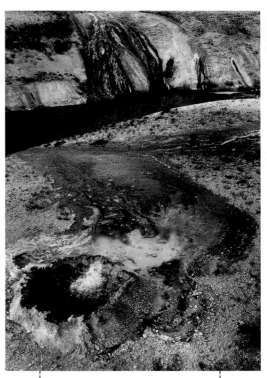

Same settings as above,
as viewed in Monochrome mode

The camera's capability to view the scene in the LCD before taking the photo (known as Live View mode) can make a real difference in your work. This is especially helpful when you are wondering how a color photo might look as a black–and-white image. The photo above, among the geysers in Yellowstone, is fine in color, but you could preview it in black and white by switching your camera to record in Monochrome mode (right). If shooting a JPEG, the camera will process the image as black and white; if shooting in RAW format, you will have the option to create the image in color or black and white.

*Exposure Mode:* Manual
*Aperture:* f/18
*Shutter Speed:* 1/200 second
*ISO:* 200
*Metering:* Center-weighted
    Averaging
*White Balance:* Auto

**did u know?**
Each image you photograph goes through a process of perception (seeing what inspires you to make the photo), recording (a sketch of the scene as made by the camera), and processing (your final visual statement).

Recording in RAW and learning to work on an image using RAW conversion software will show you how much data the image file has to offer. It allows you to adjust the photo so it looks as you imagined it when you first saw the scene. You have the power to make every image your customized, personal view of the world.

The top photo above is an image directly from the camera with no processing applied in the computer. It is fine, but more could be done to enhance it. The lower picture is an interpretation of the image that more closely matches my original vision of the scene, showing all the brilliance of color and light in nature. The difference between recording and perception is in the way that you treat the image after downloading. Here, for example, I enhanced color saturation and increased contrast. The aim of these adjustments was to recreate the visual feel of the moment.

# 1.2 RAW is Amazing

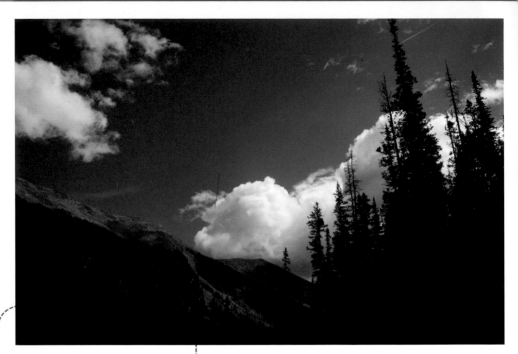

*Exposure Mode:* Aperture Priority
*Aperture:* f/16
*Shutter speed:* 1/160 second
*ISO:* 100
*Metering:* Center-weighted Averaging
*White Balance:* Shade

**There are generally two** file formats available in your camera when making photographs—JPEG and RAW.

JPEG is for those who want to shoot without doing a lot of image processing in the computer, and for those who want to print the photos using kiosks or online services (rather than printing on your home inkjet printer). Most D-SLRs offer in-camera image adjustments when recording JPEGs. You can also make additional image-processing changes to the JPEG with computer programs such as Photoshop (and others) if you want. But when you

## Tools:

- A camera capable of recording in RAW format
- A computer program that can process RAW files

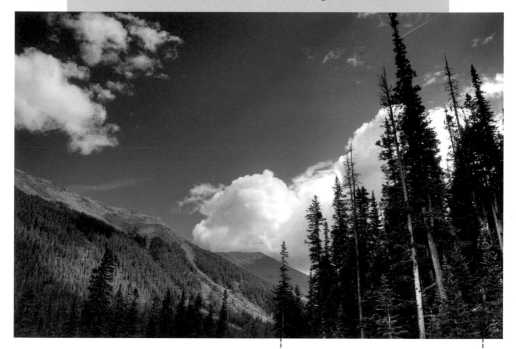

*Selective Adjustments:* This displays the result of enhancements that can be made to your digital file.

process a JPEG in either case, you are changing the structure of the file itself, which is considered a limitation by many photographers.

On the other hand, RAW files afford much more opportunity for image enhancement. They contain much more digital data in terms of color, brightness, and other image attributes. Unlike JPEG files that are compressed in the camera and therefore lose image information, RAW are edited using a non-destructive method within the RAW conversion program in your computer. Consequently, virtually no information is lost from the digital image file. You can then save the processing applied to your RAW files as JPEG or TIFF copies, keeping your original intact.

However, RAW files are big, and therefore take up much more memory than JPEGs. Also, they are proprietary, meaning that each camera manufacturer produces their own version. In addition, you must process and convert the image prior to printing or sharing it in any way (while JPEGs can be viewed by nearly any computer in existence).

Software for processing RAW files is usually included from the manufacturer when you buy your camera, or particular programs can be purchased separately through third party producers, such as Adobe or others.

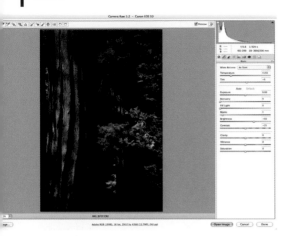

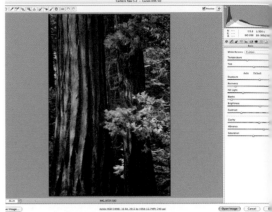

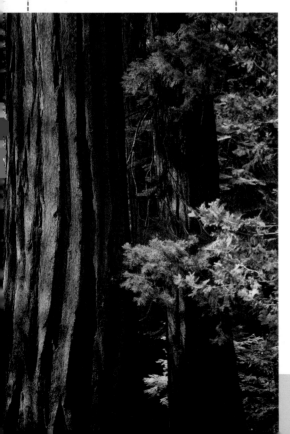

Aperture: f/5.6
Shutter Speed: 1/320 second
ISO: 200
White Balance: Auto
Metering: Center-weighted Averaging

The illustration above and to the left shows the camera's exposed image as it appears in Photoshop's Camera Raw workspace. I metered the scene with the camera to preserve detail and texture in the highlights, but the shadows came out quite dark. Recording and processing this as a RAW file, I knew I could take advantage of the abundant image data to bring out more detail and brighten the dark colors so that the picture would look more like the scene as my eyes saw it. Note how many attributes of the file can be changed in RAW processing, as listed in the panel to the right of the image. Using those controls is like changing the camera settings for recording the image—the sliders alter the instructions of how I want to process the image, but they do not change the actual image data (above right).

In total, I spent about 15 seconds working on this image in Camera Raw. I certainly feel it is time well spent. I converted the final image to a TIFF file for transport to my editor and publication in this book (left).

The processing works just as well for over-exposed scenes. This photo of a mountain reflection in Yosemite National Park is a bit washed out in both color and exposure (right). But because it was a RAW file, I was able to quickly enhance the color and add contrast, brighten and saturate the greens, and even invert the image—all within several seconds (below). True, it does take some practice and experience to be able to process your images quickly, but it is more than worth the investment in time and energy.

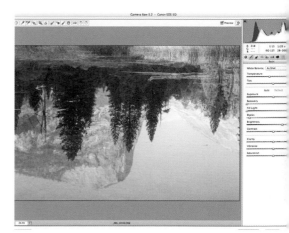

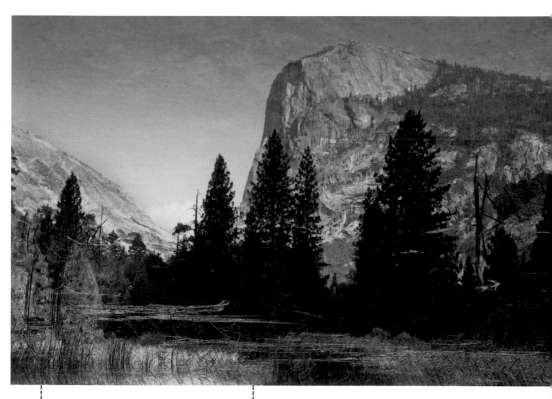

*Aperture:* f/13
*Shutter Speed:* 1/25 second
*ISO:* 125
*White Balance:* Daylight
*Metering:* Center-weighted Averaging

# Producing the Best in Color and in B&W

**2**

olor is more than the hue of the subjects in your photograph. It is the mood of the prevailing light source, the play of shadow and light, how the subject surface reflects that light, and the way in which colors clash or complement one another in your images. Color is as much a creative tool as exposure, focus, and point of view. It can be controlled and modified in the camera, or later in software, to be as expressive as you like—even to the point of its removal to create dramatic black and white images.

Every digital photograph is a color photograph. The red, green, and blue components are integrated together in ways that create a continuous tone image; yet, those components can also be changed in numerous ways to enhance the image you recorded, from creating pale pastel to super-rich color renditions, and using in-camera tools to emulate effects used by master black and white photographers.

# 2.1 Recording Autumn

## Using in-camera tools to enhance color

## Tools:

- White Balance Options:
  - Daylight  • Cloudy  • Shade

- Menu Options:
  - Contrast  • Color Saturation  • Picture Styles
- Exposure Lock
- Exposure Compensation
- Zoom Lens

**Fall is all about color, design,** and the interplay of light and shadow as the sun shines upon the foliage. The idea, to me, is not to document the season, but use the natural conditions of autumn as a foundation for texture, reflections, and contrasting relationships between colors. To enhance these colors, you can work with your photography to control color rendition, color space, saturation, white balance, and contrast settings. You can manipulate any or all of these options to create as fanciful a rendition of the scene as you desire.

*Exposure Mode:* Aperture Priority
*Aperture:* f/11
*Shutter Speed:* 1/250 *ISO:* 100
*Metering:* Center-weighted
  Averaging as framed
*White Balance:* Daylight
*Picture Style:* Vivid
*Saturation:* +1

*Exposure Mode:* Aperture Priority
*Aperture:* f/11
*Shutter Speed:* 1/250
*ISO:* 100
*Metering:* Center-weighted
  Averaging as framed
*White Balance:* Cloudy
*Picture Style:* Vivid

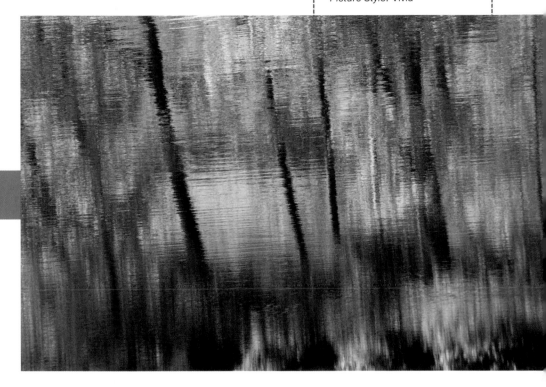

Increasingly, cameras have items known as "Picture Styles" or "Picture Controls" that bundle the various image attributes into one processing set. For example, several camera manufacturers have a Vivid style that saturates certain colors. This is an in-camera process that is quite apt for fall images. Or, many cameras allow you to set up your own processing instructions, where you might opt to select a warmer than usual white balance (perhaps Cloudy or Shade), set increased color saturation and contrast, and even nuance white balance by making a custom setup on your own. You usually have the capability to store this group of custom settings as a particular style, sometimes giving it a label or name, in the camera's memory. In this case you might call it AutumnColor, and apply it to future foliage photos.

*Exposure Mode:* Aperture Priority
*Aperture:* f/16
*Shutter Speed:* 1/250 second
*ISO:* 100
*Metering:* Spot reading on bright yellow leaves
*White Balance:* Cloudy
*Picture Style:* Vivid
*Contrast:* +1.5.

### did u know?

After locking exposure by pointing the camera and holding the shutter button half-way down, I reframed the scene to produce the composition I found most pleasing.

*Exposure Mode:* Aperture Priority
*Aperture:* f/5.6
*Shutter Speed:* 1/2000 second
*ISO:* 100
*White Balance:* Shade
*Metering:* Spot reading off leaves
*Picture Style:* Landscape
*Contrast:* +1
*Saturation:* +1

### did u know?

With the autofocus point set on the leaves floating in the pond, the water's surface and background become blurred (soft) due to the shallow depth of field produced by the relatively wide aperture used with a focal length of 200mm.

Using the surface of a pond or lake is a great way to record the colors of autumn. The water is like a canvas onto which colors are painted, allowing many different photographic interpretations.

The surface might be still, or stirred by a breeze; it might be filled with multiple colors reflected from the surrounding trees, or perhaps mostly deep and dark, with leaves scattered across the top to catch the slanting fall sunlight. You can alter the relationship of light to dark via contrast settings, or change the color cast to influence the mood and character of light in each scene.

# 2.2 In-Camera Color Saturation:
## Adding Vitality to Your Images

## Tools:

- In-Camera menu:

  Color Saturation Control

  Picture styles, Creative styles, Picture control, Parameters (Each Camera brand names these differently).

- Landscape scene mode

*Exposure Mode:* Manual
*Aperture:* f/11
*Shutter Speed:* 1/80
*ISO:* 200
*Metering:* Center-weighted Averaging
*White Balance:* Auto
*Saturation:* Set to -1.5 on a linear scale

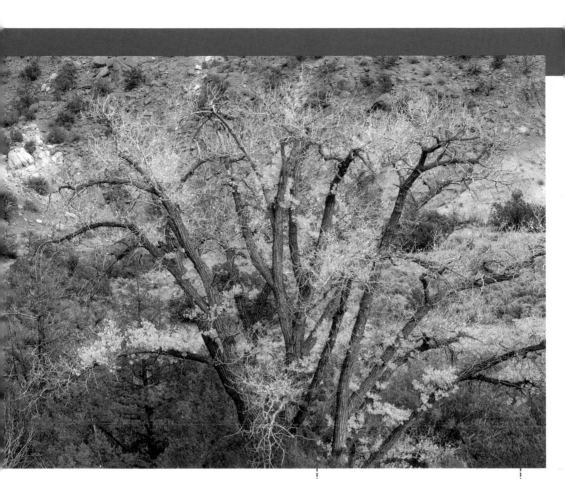

## Saturation refers to how vivid

a color is. This intensity of color could vary from soft and delicate, like a pastel drawing, to bright and bold, as an acrylic painting. Or, think of a mural that has been on a sun-drenched wall for years, compared to when it was freshly painted. As you can imagine, there are degrees of saturation; and every scene, subject, and lighting condition will inspire you to work in these various degrees.

*White Balance:* Shade (adds warmth to image)
*Saturation:* Has been raised to +1.5 on a linear scale

### did u know?

You can easily test your camera to see how it performs in terms of applying saturation. Take several JPEG pictures of the same scene (use a tripod if you have one), but change only the saturation setting for each shot. Do no other processing and compare the results.

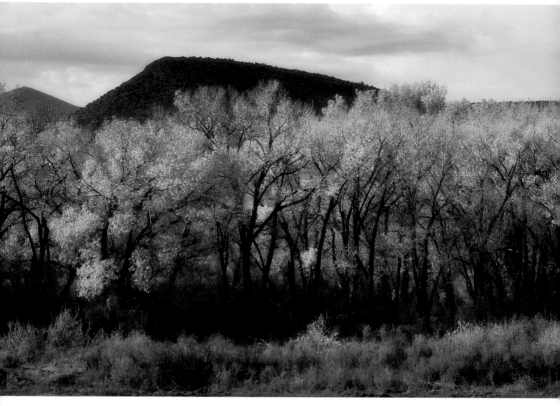

Most cameras have a menu setting that lets you adjust the level of color saturation to apply to your JPEG image (as well as similar settings for contrast, hue, and sharpness), often on a +/– linear scale. If recording in RAW, use this control as a starting point. You can add or subtract saturation in both RAW and JPEG images later with processing software, although using RAW allows more leeway for making enhancements.

In addition, many cameras allow you to assign a level of color saturation by using menu settings for a control that goes by various names, such as Creative Styles, Picture Styles, or Picture Mode. Depending on your camera make and model, these settings may have names such as "Vivid," "Natural," "Muted," etc. Setting saturation in the camera like this affects the degree of vividness for all the colors in your image, though I have found that red, yellow, and orange tend to be more sensitive to this control than blues and greens.

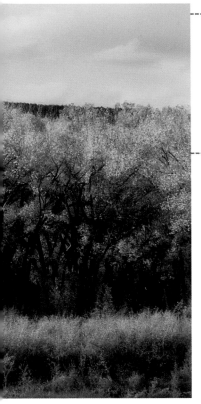

*Exposure Mode:* Manual
*Aperture:* f/11
*Shutter Speed:* 1/80 second
*ISO:* 200
*Metering:* Center-weighted Averaging
*White Balance:* Cloudy
*Saturation:* +1.0
*Style:* Landscape

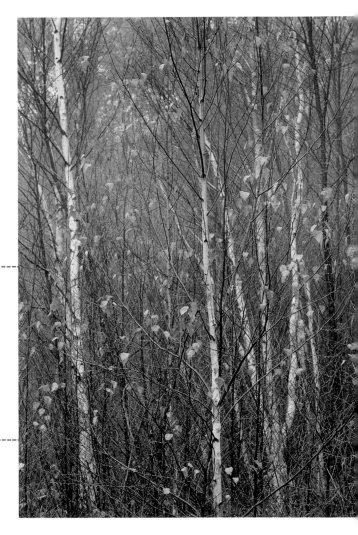

*Exposure Mode:* Aperture Priority
*Aperture:* f/7.1
*Shutter Speed:* 1/60
*ISO:* 400
*Metering:* Multi-segment
    (Evaluative/Pattern)
*White Balance:* Auto
*Saturation:* –2
*Style:* Neutral (with +1
    Sharpness control)

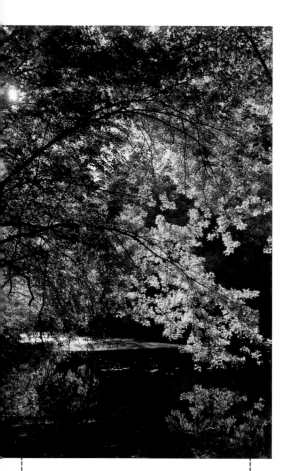

*Exposure Mode:* Aperture Priority
*Aperture:* f/16
*Shutter Speed:* 1/60 second
*ISO:* 200
*Metering:* Center-weighted Averaging
*White Balance:* Daylight
*Style:* Vivid

*Exposure Mode:* Aperture Priority
*Aperture:* f/13
*Shutter Speed:* 1/400 second
*ISO:* 100
*Metering:* Multi-segment (Evaluative/Pattern)
*White Balance:* Cloudy
*Style:* Monochrome (with +1 Contrast and Blue Tone Effect)

These style controls mean that you can choose a different saturation to affect color rendition for assorted subjects or scenes. Some of the most common in-camera selections are briefly described on the next page, listed in decreasing order of color saturation. Experiment with the menus in your camera under various lighting conditions and with different types of scenes to achieve the look you want.

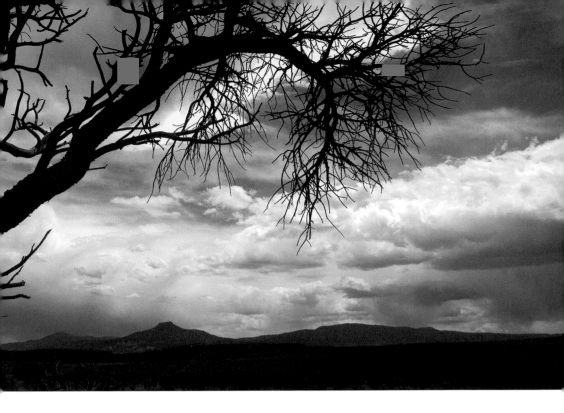

**Vivid:** All colors are darker and more intense than normal.

**Landscape:** Applies bright blues and greens, vivid yellows and reds. (Yellows and reds can be made even stronger by combining this setting with a warm white balance, such as Cloudy or Shade.

**Standard:** Bright colors.

**Portrait:** Applies less saturation, leaving colors more natural with a slightly warm color cast.

**Neutral/Muted:** Subdued, natural colors.

**Faithful:** Flat color; will definitely need post-processing to become more vibrant for land-scape and nature work.

**Monochrome:** No color shows in image, but still a color (red, green, blue: RGB) file.

You can often select and customize any of the styles or color modes and register them in the camera as user-defined menu items. These can usually be saved under a selection that is designated by the word "My," such as My Menu, My Settings, or My Mode; or simply as "memory banks" designated as 1,2,3 for three separate setups. Such custom settings can be helpful when you know how you want to record color in various scenarios, such as fall foliage, winter landscapes, scenic blue-green mountains, etc.

# 2.3 White Balance

## and Color Temperature

## Tools:

• **White Balance Settings:**
These are usually found as a camera control, set either from the menu system and/or using a button. The different white balance choices are denoted by icons:

- Tungsten
  (approx. 2000-3500k)

- Flourescent
  (approx. 3500-4500k)

- Auto WB   AWB
  (approx. 4500-7000k)

- Flash
  (approx. 5000-5500k)

- Daylight
  (approx. 5000-6000k)

- Cloudy/Overcast
  (approx. 6000-7000k)

- Shade
  (approx. 7000-10000k)

• **Image-processing Software,**
including RAW Conversion Programs

**Obviously, the light in your scene** can come from a number of different sources, including direct sunlight, shaded daylight, overhead cloud cover, diffuse fog, flash, or possibly even tungsten or fluorescent bulbs. What is less obvious, perhaps, is that each of these sources emits a different color of light. These differences are described in terms of color temperature and are measured in degrees Kelvin. When our eyes look at a scene, our brains subjectively interpret these variations in color, and everything usually appears normal. Your digital camera, however, records these different colors of light objectively, which can produce color casts in your images.

The fact that images recorded by your camera may have a color cast is not necessarily cause for alarm. There are several different ways to deal with this, either in-camera with white balance controls, or with software tools in the computer, especially when processing RAW files.

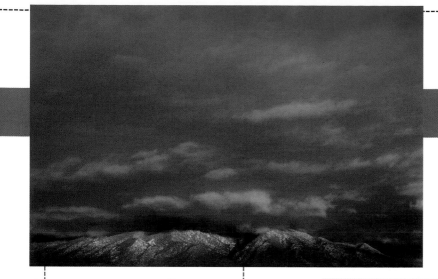

*Exposure Mode:* Shutter Priority
*Aperture:* f/8
*Shutter Speed:* 1/500 second
*ISO:* 100
*Metering:* Center-weighted Averaging

### did u know?

You can experiment with creative color by recording the same scene with different white balance settings, for example Auto White Balance (above) and Daylight (below). You can produce the same effects by recording in RAW format and adjusting the color temperature using your RAW conversion software.

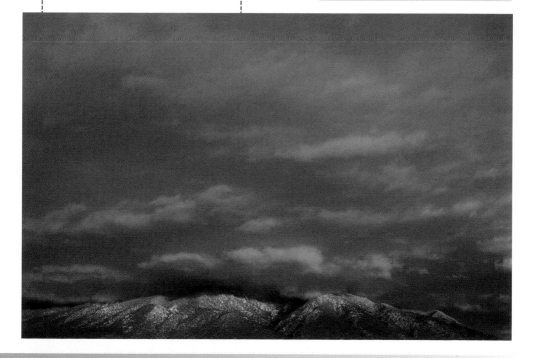

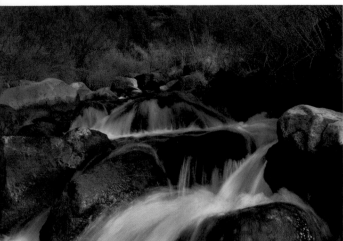

*Aperture:* f/22
*Shutter Speed:* 1/8 second
*ISO:* 100
*White Balance:* Tungsten
*Metering:* Center-weighted Averaging

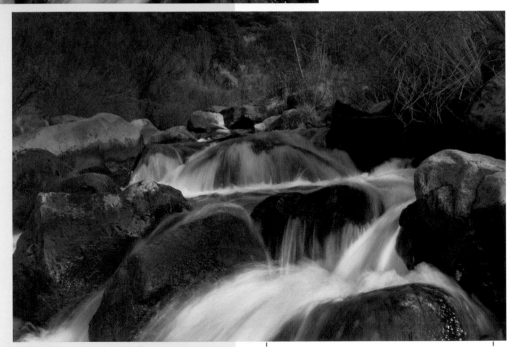

### did u know?

The effect of color in a photo can be profound, even influencing our perception about the time of day the image was made. A cool, blue color may evoke pre-dawn darkness (top); while a warmer, amber cast might lead the viewer to ponder the beauty found just before the sun sets.

*Aperture:* f/22
*Shutter Speed:* 1/8 second
*ISO:* 100
*White Balance:* Cloudy. Changed in RAW processing to emulate effect.
*Metering:* Center-weighted Averaging

Auto white balance instructs the camera's processing engine to neutralize color casts produced by the prevailing light source. But you can influence the color cast for creative ends as well, or counteract an obvious and unattractive cast, by setting your own white balance preference in the camera. For example, natural light within the shade of a forest is considered cool, with a blue cast. Setting your white balance for Shade will add amber/orange to the image, shifting the color temperature to a warmer tone and eliminating the bluish tint. However, that blue tint might in fact add to the mood of the scene, so each shot is a judgment call. Use Live View (if you have it), or take pictures with different settings and review in Playback, to see the effect of different white balance settings.

When set to AWB, the camera recorded a lemon-colored sky. But changing the white balance of the RAW file to 3000K added some blue that made for more variety in the sky.

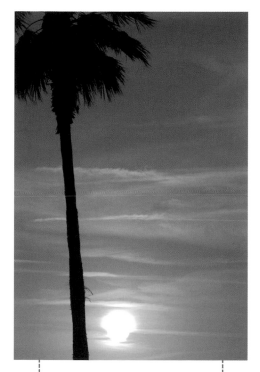

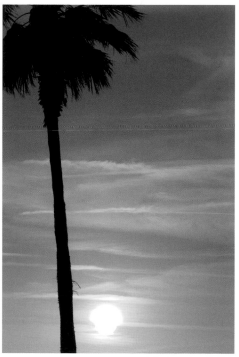

*Exposure Mode:* Aperture Priority
*Aperture:* f/16
*Shutter Speed:* 1/250 second
*ISO:* 200
*White Balance:* Auto
*Metering:* Multi-segment
   (Evaluative/Pattern)

# 2.4 Black and White

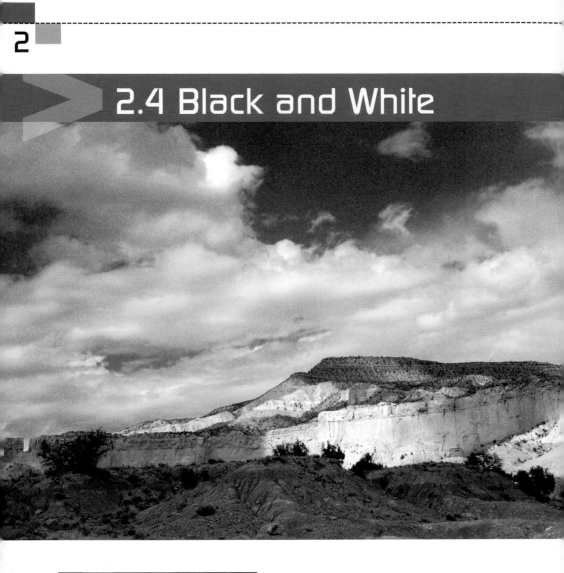

## Tools:

- Camera menu
- Monochrome recording mode
- In-Camera filters via menu system
- Image-processing software using conversion tools for black and white

**Every photograph you record** with your digital camera is a color photograph composed of three color components, or channels: red, blue, and green (RGB). That does not prevent you from making black and white photos, however, because there are numerous ways to convert color to black and white, either in the camera or later in the computer using software.

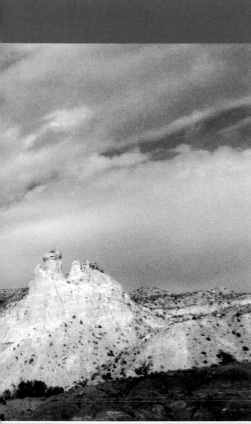

*Exposure Mode:* Manual
*Aperture:* f/14
*Shutter Speed:* 1/400 second
*ISO:* 200
*White Balance:* Auto
*Metering:* Spot

Making a black-and-white photo from one originally shot in color is no problem with image-processing software. The hues in the colored rock and the blue sky in this example can be converted into a number of different tones, depending on your idea of how the final photo should look.

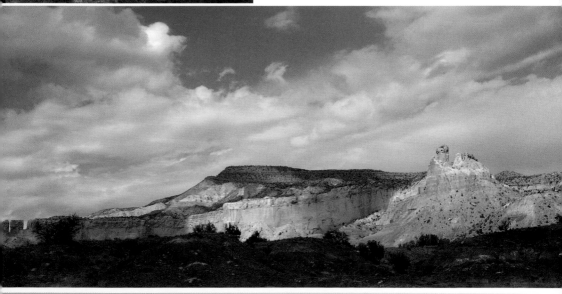

*Exposure Mode:* Aperture Priority
*Aperture:* f/16
*Shutter Speed:* 1/200 second
*ISO:* 400
*Metering:* Multi-segment (Evaluative/Pattern)
*White Balance:* Auto
*Recording Mode:* Monochrome
*In-camera Filter:* Yellow
*Contrast:* +1

To record black-and-white photos directly in your camera, choose the Monochrome option, usually found as a menu selection, perhaps under Picture Styles. With practice, you may be able to imagine what a nature scene will look like as a black and white picture even before firing the shutter. It can be helpful, however, to preview the black-and-white image on your LCD prior to exposure if you have a camera with Live View.

Though JPEGs shot in Monochrome mode are recorded using the R, G, and B channels, they remain black and white—you won't be able to convert them to color later because the in-camera processing eliminates the color information. RAW images recorded in Monochrome, however, can be processed to display in full color.

In the picture above, the rising sun was casting its light on the snow-clad trees. While the sky was a pleasant blue, I chose to record in Monochrome to give the image a stark, wintry feel. I also set a Yellow filter effect and +1 Contrast to record this image.

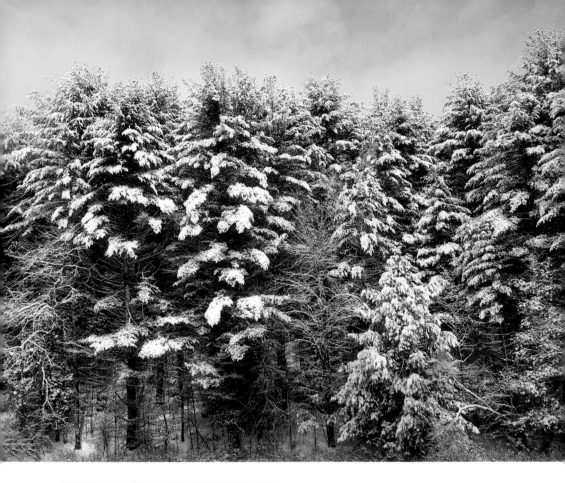

**Black & White** Custom

☐ Tint    Auto

Reds:     60
Yellows:  98
Greens:   40
Cyans:    -18
Blues:    -51
Magentas: 80

**did u know?**

There are a number of sophisticated image-processing computer programs, including RAW conversion software, that can convert from color images to black and white. The dropdown tool found in Photoshop (Image > Adjustments > Black & White; or Layer > New Adjustment Layer > Black & White) uses sliders so that each original color in the image can be adjusted to become a lighter or darker tone in the black-and-white picture, allowing a great deal of control and a multitude of creative interpretations.

# 2.5 Enhancing Black and White
## with Digital Filters

**When shooting with black-and-white film,** photographers place filters over the lens to affect the density or gray-scale tonal rendition of the colors. These color contrast filters work by allowing light of their own color to readily pass, while blocking the light of complementary colors. For example, a red filter is used to dramatically deepen a blue sky, passing red wavelengths but blocking blue. The sky will register on film with less density (less exposure), and will therefore print darker than normal. Or, a green filter is used to enhance green foliage because it passes more green light, so the green areas reveal more detail.

With digital cameras, many give you the option when recording in Monochrome mode to select in-camera filter controls (usually found in the menu system), including yellow, green, red and, on some models, orange. These controls have nothing to do with density, but are software enhancements that emulate the effects you'd produce when using color contrast filters with black-and-white film.

## Tools:
- Camera menu
- Monochrome recording mode
- In-Camera filters via menu system
- Image-processing software using conversion tools for black and white

*Exposure Mode:* Shutter priority
*Aperture:* f/2.8
*Shutter Speed:* 1/500 second
*ISO:* 200
*Metering:* Multi-segment (Evaluative/Pattern)
*White Balance:* Auto
*Filter:* Sepia filter effect
*Lens:* Lensbaby

You can often apply in-camera filter effects that add color to an image recorded in Monochrome mode, tinting it in tones such as sepia or blue. This tree was filled with colorful blossoms in spring, but I felt a sepia-toned black and white would make an interesting rendition.

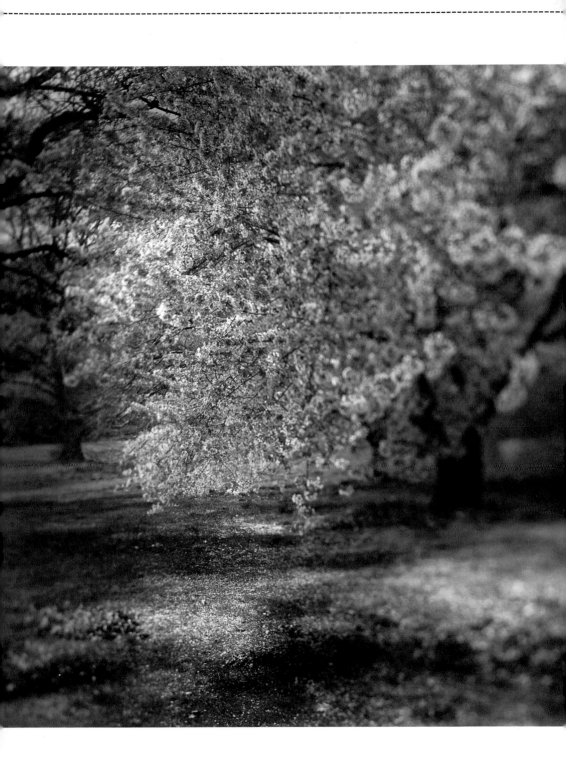

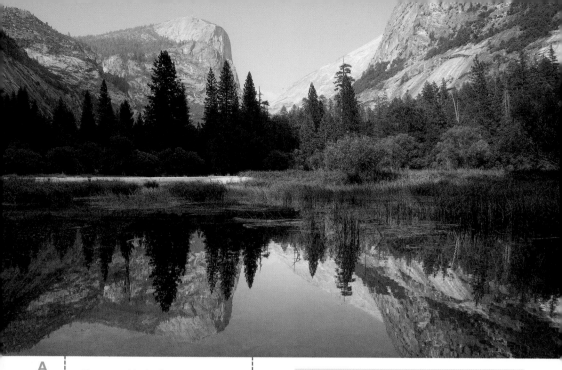

**A**

*Exposure Mode:* Aperture Priority
*Aperture:* f/13
*Shutter Speed:* 1/200 secontd
*ISO:* 125
*Metering:* Multi-segment
  (Evaluative/Pattern)
*White Balance:* Daylight

**did u know?**

Digital filter options abound both in your camera and in computer processing programs. Different filters alter the brightness values of such elements as trees, sky, and water in your landscape photos. Knowing when to use these effects will make a dramatic difference in your monochrome images.

The series of images showing the mountain lake demonstrates the effects of different digital color filters: (A) no filter effect; (B) blue filter; (C) green filter; and (D) red filter.

Keep in mind, however, that these in-camera filter effects are pre-set by the camera, and therefore may not be exactly what you have in mind for tonal conversion to black and white. You will have more control over the exact conversion of most colors by shooting in RAW format and converting to black and white in the computer. But, using these filters to previsualize the image in Live View can be a great aid in making effective black-and-white images.

**Tip**
Use Yellow, Orange, or Red filter effects to make a blue sky look progressively darker (without affecting the clouds). Also, you can strengthen any filter effect by increasing the in-camera Contrast parameter.

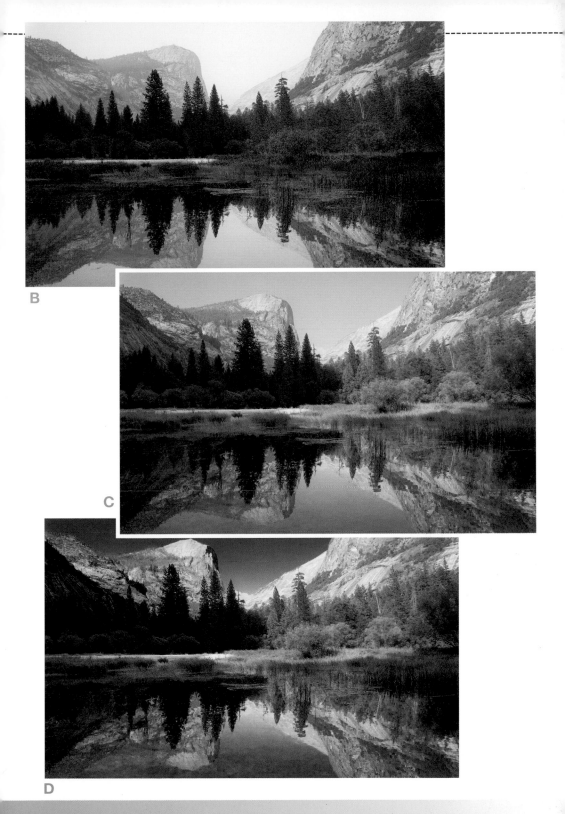

B

C

D

# Capturing Great Light

**L**ight, and the way it is rendered in an image, is what photography is all about. To understand photography, it really helps if you take some time to study light, a pursuit that will soon lead you to look at the world in completely new ways.

This section deals with a variety of lighting conditions and how you might approach them in your photography. Given that every moment is unique, and that light is ever changing, there is no way to make easy rules or formulas that work perfectly for every situation or lighting condition. The intent is to consider the effects of light and to help you understand that the way the camera records light can be quite different than the way you actually see it, and to suggest ways you can use camera controls to narrow that gap between perception and recording.

# 3.1 Making Beautiful Photos
## with Backlight

**Backlight comes toward your camera's lens** from behind your subject. It is often one of the most beautiful lighting conditions, helping you create pictures that have a magical quality. But you need to be careful; it can also cause problems with exposure.

## Tools:

- Spot metering
- Exposure compensation
- Autoexposure lock (AEL)

Think of stained glass windows in a church. They are rather dark and dull when the sky is overcast, but they can be glorious when the light comes through them. The same occurs in nature when subjects are translucent, allowing the light to come through; or even when the main subject blocks the light but you can still see a rim of light—a halo effect—around its edge.

Backlighting is inherently contrasty, meaning there will be a considerable difference in exposure between portions of the subject and the light behind it. In some instances, this means that your subject may be either a silhouette (having form but no detail), or be considerably underexposed. The key to exploiting backlighting is to use the shadows it casts toward the camera as part of the composition and expose for the light itself.

True, you could use flash to fill the subject with light, but that defeats the purpose and dramatic potential of this kind of lighting.

Perhaps the season in which to use backlighting most advantageously is fall, when the brilliant color of the foliage combines with the low-angle light coming through translucent leaves. The key is to take a meter reading from the backlit leaves and avoid measuring shadow areas for exposure. To do this, select the spot metering mode and lock exposure on the brilliant light of the leaves. In most cases this will be the proper exposure.

You can shoot using automatic exposure and spot metering and lock it for each shot or, once you review the exposure, you can lock it in by switching to manual exposure mode to maintain that exposure as you continue to shoot.

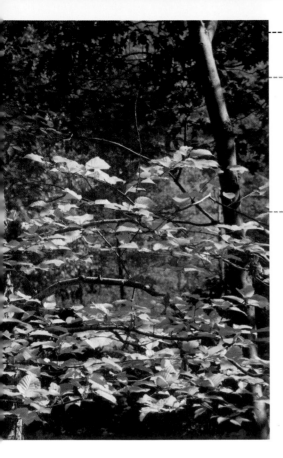

*Exposure Mode:* Aperture Priority
*Aperture:* f/27
*Shutter Speed:* 1/250
*ISO:* 1600
*Metering:* Spot
*White Balance:* Daylight
*Focal Length:* 300mm equivalent
   focal length

### did u know?

Using a telephoto focal length will compress your composition, producing interesting and out-of-the ordinary landscape photos. See page 100 for a discussion of equivalent focal length.

### did u know?

Reflections from water can sometimes provide natural fill light for the darker parts of the scene.

*Exposure Mode:* Aperture Priority
*Aperture:* f/27
*Shutter Speed:* 1/180
*ISO:* 1600
*Metering:* Spot
*White Balance:* Cloudy

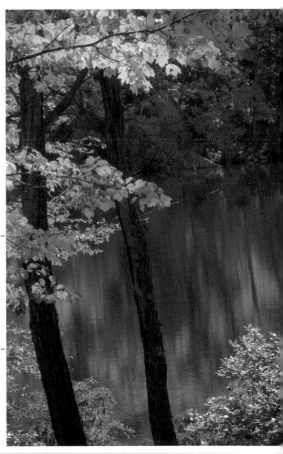

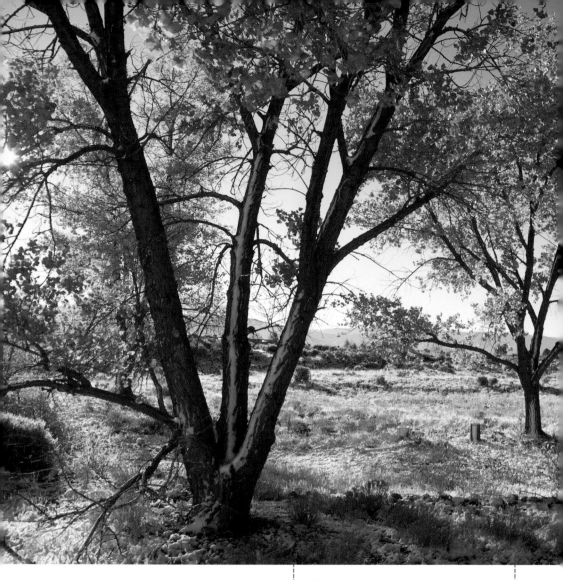

In some instances when using spot metering on bright fall leaves, you might want to use a plus (+) exposure compensation to add some brightness to other parts of the scene. This compensation should rarely go above +0.5EV.)

*Exposure Mode:* Aperture Priority
*Aperture:* f/11
*Shutter Speed:* 1/250
*ISO:* 100
*Metering:* Spot, reading from leaves in center of tree
*White Balance:* Cloudy

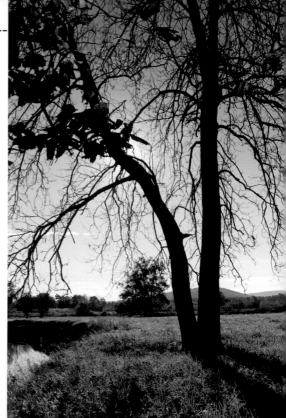

*Exposure Mode:* Aperture Priority
*Aperture:* f/16
*Shutter Speed:* 1/360
*ISO:* 200
*Metering:* Spot, reading from grass in bright area just below horizon line
*White Balance:* Daylight

When dealing with backlight, glare from direct rays of the sun will sometimes cause exposure difficulty. It is essential to block the sun from both the image frame and from exposure consideration. I often do this by finding a foreground subject to block the sun and stand within the resulting shadow to make the picture. This not only helps eliminate flare, but also insures that exposure will not be overly influenced by the direct light that is aimed at the camera. In both of these shots, I used a branch to block the sun while positioning myself so the lens was in the resulting shadow that was cast.

**Do not look through your viewfinder directly at the sun.**

Tip

# 3.2 Deep Shadows
## Produce Extraordinary Compositions

**Negative space is generally defined** as shadow areas so dark they are without content. While the connotation of the word "negative" might imply the space has no purpose, deep shadow in fact creates forms that help define the subject within the frame. While there are definitely times when you want to expose your picture to show detail in the shadow areas, any deep shadow can take on a life of its own and have shape and volume that can be as important to the composition as the visible content. These black shadows can also interrupt the rectangular frame by spilling into the edges and making curved, triangular, and truncated patterns.

To use deep shadows effectively, the contrast in the scene must be high enough so that no detail is evident within shadows when the image is properly exposed for the highlight areas (exposure readings should be made from the brightest part of the frame). This generally means use of the spot metering pattern; or, if the brightness spreads far enough throughout the frame, center-weighted averaging might be used. Use the Autoexposure lock (AEL) function to hold exposure where you have metered and move the camera to recompose as necessary. If need be, a minus (-) exposure compensation can be applied as well.

## Tools:

- Spot metering
- Center-weighted Averaging metering
- Exposure compensation
- Autoexposure lock (AEL)

*Exposure Mode:* Aperture Priority
*Aperture:* f/18
*Shutter Speed:* 1/200 second
*ISO:* 200
*Metering:* Center-weighted Averaging
*White Balance:* Daylight
*Autoexposure Lock (AEL)*

Because I wanted to control the highlights in the sunlit ocean, I made sure not to overexpose them. This meant the shadow areas in the scene became underexposed, producing negative space in the form of a silhouette, and adding drama to the jagged rock formations in the foreground. This is an example of how the light, composition, and exposure all work hand in hand.

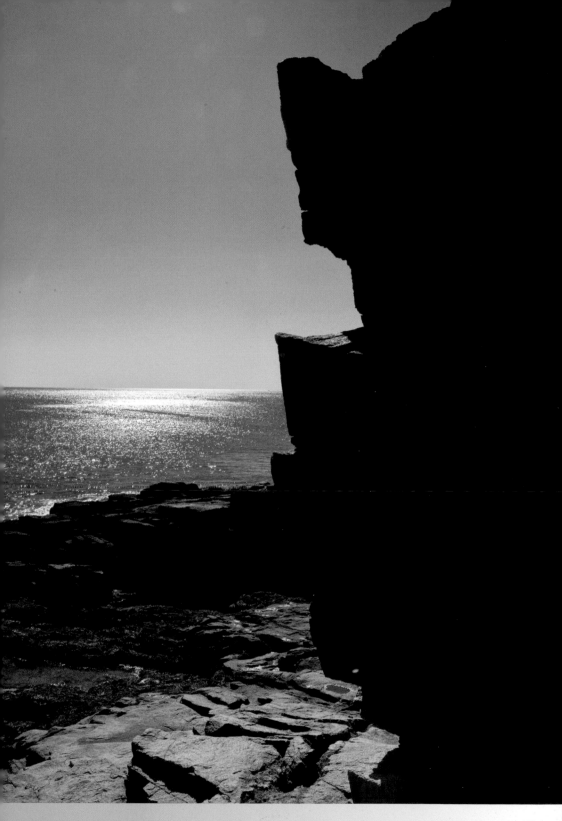

**3**

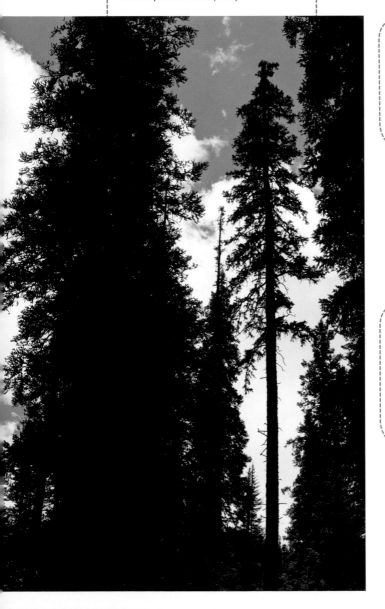

*Exposure Mode:* Aperture Priority
*Aperture:* f/16
*Shutter Speed:* 1/250 second
*ISO:* 100
*Metering:* Spot, reading off cloud
*White Balance:* Daylight
*Autoexposure Lock (AEL)*

The sense of being deep in this stand of trees is heightened by the use of shadow, form, and composition.

*Exposure Mode:* Manual
*Aperture:* f/16
*Shutter Speed:* 1/250 second
*ISO:* 100
*Metering:* Spot, reading off green pond surface
*White Balance:* Shade

*Exposure Mode:* Aperture Priority
*Aperture:* f/16
*Shutter Speed:* 1/160 second
*ISO:* 100
*Metering:* Center-weighted Averaging
*White Balance:* Auto
*Exposure Compensation:* -1EV

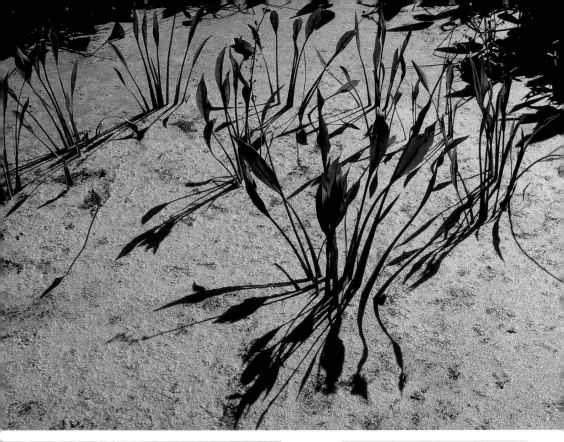

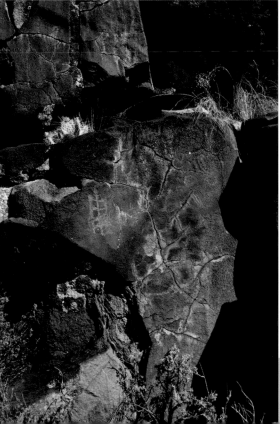

Low-angle light from the sun as it shines across the pond's surface creates interplay between the plants and the shadows they cast. The shadows give the image its rhythm and define the compositional forms.

The midsummer sunlight in the Rio Pueblo River Valley at 8,000 feet is so bright that almost any shadow in the scene will lose detail. Knowing this, I used the lighting conditions to help compose patterns of light and dark in this photo of a rock with petroglyphs near Taos, New Mexico.

# 3.3 Making Low Light

## Work for You

**Even though digital cameras,**

many now equipped with built-in image stabilization and increasingly improved image quality at high ISO settings, allowing you to produce decent candid shots in dim light, the fact remains that the best image quality results from recording at the lowest ISO possible and, when shooting in low light, using a sturdy tripod.

Despite the recent improvements in digital sensor technology, recording with high ISO settings still leads to increased noise and increased image contrast, with accompanying loss of color fidelity. Noise can also make its presence seen with exposure times longer than one second. And while image stabilization can help decrease camera movement to a point, there are thresholds to its effectiveness that depend, among other factors, on your own steadiness and the focal length of the lens in use. When shooting at long equivalent focal lengths, shutter speed becomes critical because the minimum speed at which camera shake becomes evident is considerably faster than with a wide-angle lens, which means you will have to open your aperture (producing decreased depth of field) or increase your ISO setting (potentially adding noise) to properly expose your landscape.

*Exposure Mode: Aperture Priority*
*Aperture: f/16*
*Shutter Speed: 1/15 second*
*ISO: 200*
*Metering: Center-weighted Averaging*
*White Balance: Daylight*

The dark coulds resulted in low light, but mounting the camera on a tripod allowed me to set a narrow aperture for deep depth of field and get a steady shot at 1/15 second.

# Tools:

- Tripod:

   If lens is heavy and/or has long focal length (over 150mm), tripod should be attached via lens collar

- Multi-segment (Evaluative/Pattern) Metering

- Exposure Compensation:

   When necessary to insure that meter does not overexpose low-light areas

Though my advice is to use a tripod, it may not be practical in all situations. When you must handhold the camera, use the "1/focal length" technique:

- Set your exposure mode to Shutter Priority.
- Determine the focal length you want to shoot at; for example, 200mm.
- If using an APS-C or smaller sensor, multiply the focal length by a factor of at least 1.5 to derive an equivalent focal length (actually, let's say by a factor of 2, just to be safe). Our example is now 400.
- Make this number the denominator in a fraction with 1 as the numerator: 1/400.
- So, 1/400 second should be the minimum shutter speed setting to avoid blur due to camera shake. You may have to round to the next fastest speed, 1/500, depending on the shutter speed choices offered by your camera.

This rule does not apply when shooting with a super-wide angle lens like a 12mm. A shutter speed of 1/30 second is minimum for most people.

*Exposure Mode:* Aperture Priority
*Aperture:* f/5.6
*Shutter Speed:* 1/30 second
*ISO:* 100
*Metering:* Center-weighted Averaging
*White Balance:* Shade
*Contrast:* +1
*Color Saturation:* +1
Tripod

*Exposure Mode:* Aperture Priority
*Aperture:* f/8
*Shutter Speed:* 1/30 second
*ISO:* 200
*Metering:* Multi-segment
  (Evaluative/Pattern)
*White Balance:* Shade
Tripod

### did u know?

Mounting your camera on a tripod often allows you to use a low to modest ISO setting, which usually insures better image quality. Without a tripod, you may need to raise the ISO in order to have a shutter speed fast enough to eliminate blur due to camera shake, but that would likely introduce unwanted noise.

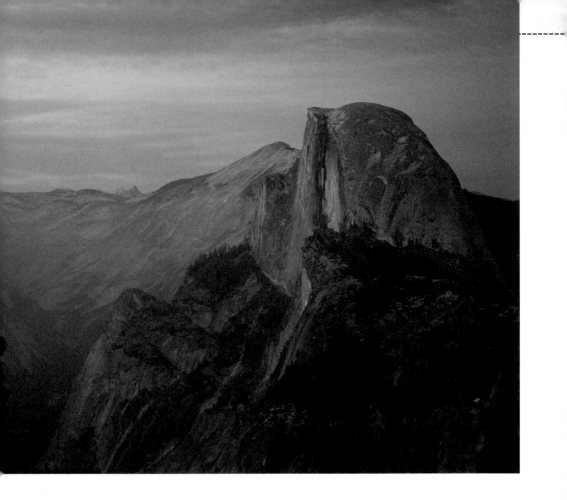

What about using image stabilization lenses or a camera with a built-in image stabilization system? You can safely add two stops to the technique described, but my advice is not to go below 1/15 second in any case with a wide lens. In the previous example using a 200mm focal length, adding two stops would mean you should be able to safely handhold at 1/125 second.

In the photo above, I wanted an aperture setting that would produce sharpness from the silhouetted trees in the foreground to the mountain ridges in the background. Using a 300mm focal length, minimum handhold-able shutter speed is about 1/500 second, or

about 1/125 to 1/60 second with an image stabilized system. Under the existing lighting conditions, I would have needed to set ISO at 3200 to properly expose using an aperture of f/8. A tripod eliminated these considerations, allowing me to record the image at a much lower ISO and my desired depth of field.

A long lens and low light should tell you to bring out the tripod. Scenes like this can be enhanced by increasing contrast, setting Shade white balance, and applying additional color saturation, which is a type of color contrast increase. All these adjustments can be done in the camera, or later during RAW processing.

# 3.4 Flat Light

## Does Not Mean Dull Pictures

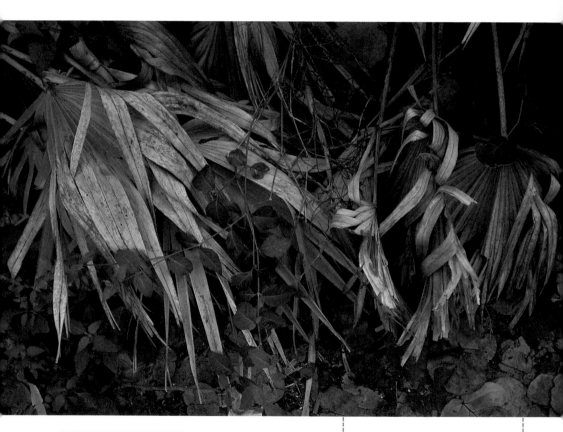

### did u know?

Don't discount flat lighting conditions. In fact, many color photographers prefer it because it eliminates some of the contrast problems found under bright light. If not shaded by the forest canopy, the white fronds in this picture might have lost detail under direct light. The existing flat light eliminated this potential problem, producing a richly colorful result.

*Exposure Mode:* Aperture Priority
*Aperture:* f/8
*Shutter Speed:* 1/60 second
*ISO:* 400
*Metering:* Multi-segment (Evaluative/Pattern)
*White Balance:* Daylight, made slightly warmer in processing

## Tools:

- Multi-segment (Evaluative/Pattern) metering
- ISO sensitivity
- In-camera contrast
- White balance
- RAW processing

**Flat light is ambient light** that creates little or no contrast throughout the scene, so there is less difference than normal between the brightest and darkest tones. It is the light you will experience under a forest's canopy, on overcast days, or when the scene is shaded by a high canyon wall or similar feature. Some photographers become discouraged about shooting in flat light because colors might seem dull and there's little contrast to catch the eye. But that does not need to be case.

Fortunately, digital photography addresses the issue of flat light quite effectively because it is a simple matter to alter image contrast for each frame, either at the time of exposure, or after, when the image is processed in the computer. In fact, it is perhaps the easiest light in which to make photographs.

Recording in RAW format gives you the most post-exposure processing options. You can shoot in any autoexposure mode and use Multi-segment (Evaluative/Pattern) metering pattern, as the lower contrast will pose no exposure problems.

If the light is very dim, especially if you don't have a tripod, consider raising ISO to allow faster shutter speeds or increased depth of field (see the discussion on page 56).

Canyon walls are a favorite subject of mine, with their weathering and colorful designs. When shooting in shadow, the color can shift to a blue cast and contrast can be low. Notice the difference in these two images, where the defaults (right) for white balance, contrast, and color have been adjusted to Cloudy, +1, and +1, respectively (below).

*Exposure Mode:* Aperture Priority
*Aperture:* f/8
*Shutter Speed:* 1/60 second
*ISO:* 400
*Metering:* Multi-segment (Evaluative/Pattern)
*White Balance:* Auto

*White Balance:* Cloudy
*Contrast:* +1
*Saturation:* +1

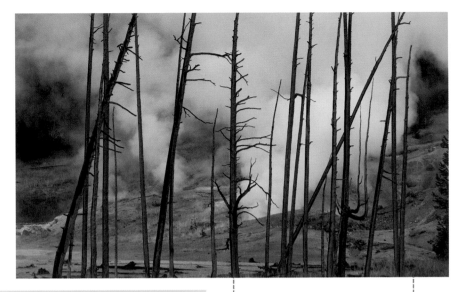

Don't let inclement weather stop you from shooting color outdoors. This original photo (above) was made in Yellowstone National Park on a heavily overcast, rainy day. The photo is livelier with adjustments of +2 saturation on selected areas and +2 contrast on the overall image made in a RAW processing program (below).

*Exposure Mode:* Aperture Priority
*Aperture:* f/11
*Shutter Speed:* 1/30 second
*ISO:* 200
*Metering:* Multi-segment
  (Evaluative/Pattern)
*White Balance:* Cloudy

*Contrast:* +2
*Saturation:* +2

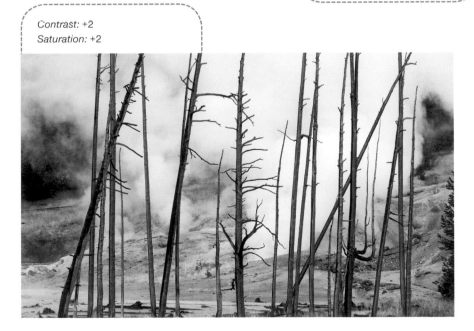

# 3.5 Making Outstanding Photos
## in Harsh Light

## Tools:

- Picture style: Contrast control customization
- Tone curve compensation function, or similar in-camera process, depending on camera model (sometimes called D-lighting)

**Since high contrast conditions** can cause exposure problems, it's good to know about certain in-camera controls that can ameliorate them, at least to a degree. I learned this while shooting photos in the shady canyons of the American Southwest and in the sunlight of the Florida Everglades. My camera at that time had a contrast default that was quite aggressive, so I had to control it by dialing back the contrast using a custom setting in the Picture Styles. It was a habit I carried forward with other cameras, even those with a lower contrast default, and it's helped tame some otherwise very difficult lighting conditions. Experiment with your camera to see if you get the same benefits. Keep in mind that if you record in RAW format, you can always make these settings later when processing the image.

There are two primary ways to control contrast in the camera, both of which affect the contrast curve when the JPEG is processed. One way is to go into the Picture Style (or similar menu depending on your particular camera) and choose the Contrast control. The sliders usually range between –2 and +2 on either side of the default setting. You will have to test your camera to see the actual effects, and keep in mind that other settings, such as saturation and even sharpening, can affect contrast as well.

Built-in processing algorithms pose another way to deal with in-camera contrast processing, including an automatic balancing of shadow and highlight, sometimes called Tone Curve Compensation or D-Lighting, again depending on your model of camera. Some cameras refer to these as "filters," and use terms like "low key" or "low contrast"— they all produce basically the same effect by suppressing the highlights slightly and boosting the information in the shadows. While few controls are 100% effective, I usually use these types of filters (image-processing algorithms) when there is a lot of contrast in the scene I want to photograph.

I had been to the area where this photo was taken a number of times in the past, where I dutifully metered highlight areas and exposed +1 or +1.5EV using the exposure compensation control (left). That made for proper exposure, but left some shadow areas very dark. My solution now is to lower the contrast setting in the menu while still reading the scene to control highlights (below).

*Exposure Mode:* Aperture Priority
*Aperture:* f/16
*Shutter Speed:* 1/250
*ISO:* 100
*Metering:* Spot reading on white formation
*White Balance:* Daylight
*Exposure Compensation:* +1EV

Tone Curve Compensation (D-Lighting) at high setting

### did u know?

Light colored, reflective surfaces can produce high-contrast scenes in midday sunlight, often making exposure difficult to control. Bright areas lose detail and texture, while shadow areas may go completely black.

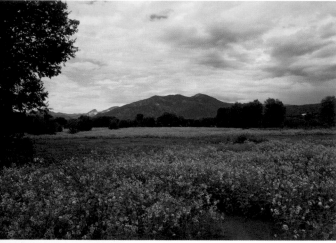

*Exposure Mode:* Aperture Priority
*Aperture:* f/11
*Shutter Speed:* 1/125 second
*ISO:* 200
*Metering:* Center-weighted
Averaging read and locked on sky
*White Balance:* Daylight

Tone Curve Compensation
(D-Lighting)

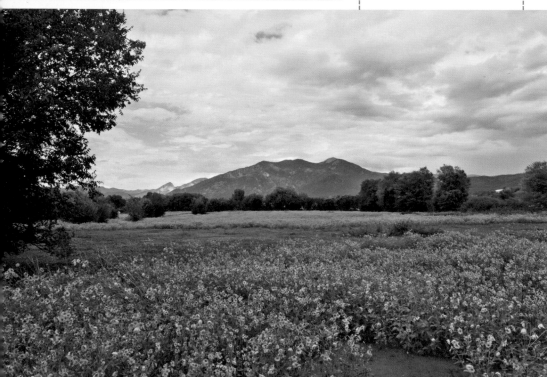

### did u know?

In-camera processing algorithms change the tone curve (contrast) either by adding more brightness to the shadow areas, or by suppressing the brightness of the highlight. Adding tone curve compensation, as seem in the bottom image, retains the highlight values while opening up the shadows. Yes, there is some effect on the highlights, but they are certainly still well in control.

Sometimes the light is so harsh that you have to try additional tools to control contrast. The scene at left shows simulated black "blinkies" where the highlights are overexposed. Rather than expose the scene to keep the highlights from losing detail, which would have brought the shadows deeper and probably created more contrast, I used Picture Styles to decrease contrast by a setting of -1.5. In addition, I activated the camera's tone contrast compensation, which opened the shadows. The combination helped control the overly harsh highlights and reveal more detail in the shadows. No doubt, it would be better to shoot in softer light, but you can't always choose the light when on the trail.

*Exposure Mode:*
Aperture Priority
*Aperture:* f/11
*Shutter Speed:*
1/125 second
*ISO:* 200
*Metering:* Center-weighted
  Averaging read and locked
  on sky
*White Balance:* Daylight

*Picture Styles:* −1.5 contrast
Tone Curve Compensation

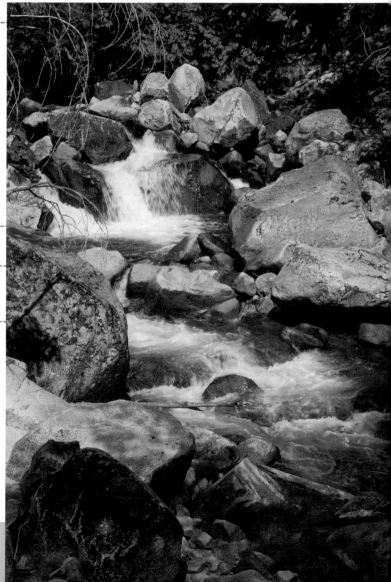

# 3.6 It's Easy to Shoot
## Great Sky Scenes

**The sky is a constant show,** but the most colorful and dazzling displays usually occur at sunrise or sunset (more likely). But it is not always easy to record the brilliance of an orange-red sunset. To avoid disappointment in what the camera delivers, as opposed to the amazing colors and tones you witness in the actual scene, use center-weighted averaging or spot metering modes to lock exposures. This will read the light you want to measure, because you might miss these luxurious tones if using more automated exposure patterns.

If you are shooting just for the sky (and that could be a life's work), consider placing some sort of natural marker or portion of horizon in the scene to give a sense of scale and to contrast with the clouds or colors in the sky. This compositional weight usually has more appeal than simply images of the sky alone.

## Tools:

- Center-weighted Averaging metering
- Spot metering
- Exposure lock

When the sky is blue and clouds are bright and fluffy, it is important to control the brightest areas at the edge of the clouds. Make a center-weighted averaging reading from the sky only, and then check the overexposure warning on the LCD in the image playback. Compensate with minus exposure compensation if you see any blinkies, dialing down until the blinkies go away. You can always add some brightness later in processing if need be.

In the scene below and the one to the right, a small portion of the ground is used to lend a sense of scale. The camera was pointed at the sky, the exposure was locked, and then recomposed.

*Exposure Mode:*
 Aperture Priority
*Aperture:* f/3.2
*Shutter Speed:*
 1/640 second
*ISO:* 400
*Metering:* Center-
 weighted Averaging
*White Balance:* Daylight

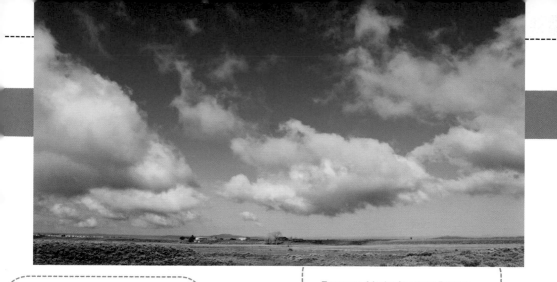

*Exposure Mode:* Aperture Priority
*Aperture:* f/8
*Shutter Speed:* 1/125 second
*ISO:* 200
*Metering:* Spot reading off
   lighted mountain peak
*White Balance:* Cloudy

*Exposure Mode:* Aperture Priority
*Aperture:* f/10
*Shutter Speed:* 1/200 second
*ISO:* 100
*Metering:* Center-weighted Averaging
*White Balance:* Daylight
*Exposure Compensation:* –0.5EV

*Exposure Mode:* Shutter Priority
*Aperture:* f/5.6
*Shutter Speed:* 1/200 second
*ISO:* 200
*Metering:* Center-weighted Averaging off sky
*White Balance:* Daylight

Here the sky is darker than the mountaintop, and the last ray of light from the settings sun illuminates the peak. This is when spot metering comes into play.

**3**

# 3.7 The Amazing Qualities
## of Infrared Light

## Tools:

- Tripod
- IR-converted camera, or Digital camera with IR-sensitivity
- IR filters for end of lens, depending on how much visible light to filter out
  - Wratten #25 red/RG 590/25A
  - Wratten #87 opaque/RG780/R72
  - Wratten #87B black/RG850/RM90
- Image-processing software

**Infrared photos have a distinctive** look, sometimes described as otherworldly or ghostly, allowing photographers to create images that are out of the ordinary. Like visible light images, IR photos derive from the camera's exposure to a certain range of wavelengths within the electromagnetic spectrum. Unlike visible light, however, IR wavelengths are invisible to your eyes—but not to a digital sensor. In fact, an internal filter in digital cameras blocks IR light. Without this high-pass (or cut) filter in front of the camera's sensor, IR would normally hinder color reproduction and saturation, as well as detract from sharpness. But you can use this characteristic to your advantage.

There are two primary ways of recording infrared images. Perhaps the easier (though more expensive) way is to mechanically have your camera converted so it records infrared wavelengths exclusively, without the need for an external IR filter. There are specialist firms that can do this, and others that simply remove the high pass filter so that you can record infrared by using red or specially made filters for recording only IR light. Many photographers dedicate a second hand or older digital camera to this function.

There are several advantages to using an IR-converted camera, especially D-SLRs. Among them are the ability to hand-hold the camera while recording IR images, the ability to compose and focus without the view being blocked by over-the-lens IR-filters, and the ability to use lower ISO settings and faster shutter speeds, thereby reducing the probability of noise and blur.

*Exposure Mode:* Aperture Priority
*Aperture:* f/16
*Shutter Speed:* 1/125 second
*ISO:* 400
*Metering:* Multi-segment (Evaluative/Pattern)
*White Balance:* Auto

# Tip

Once you have an IR-converted camera in hand, here are a few tips for getting those interesting effects:

### 1. Use Manual Exposure Mode

Proper exposure will vary depending on the brightness of existing conditions and the type of filter used to block the range of visible light, thus isolating IR wavelengths. But I have generally found that an aperture of f/11 with a shutter speed of 1/125 second works for most shots. Review your shots on the LCD and then adjust exposure accordingly. You may want to bracket your exposure settings.

### 2. Use Manual Focus

IR images can be soft because you are not recording visible light. So you often have to adjust focus a bit to produce a sharp image. With practice, you will learn how to compensate for sharper focus for your IR camera. You can always bracket aperture or stop down to increase depth of field, which can help keep objects within the scene in focus. Some photographers bracket focus as well by setting focus at different points in front of and behind the foremost subject.

### 3. Keep the ISO within reason

With an IR-converted camera, you won't need the increased exposure necessary when using a normal camera with an IR filter over the lens. Therefore, the best results are at ISO 400 or lower. Noise becomes pretty wicked beyond that.

### 4. Record in RAW format for the easiest way to process your IR images

You will need to do a bit of processing after exposure to enhance the images. Using RAW format and its conversion software gives you the most leeway in making adjustments to IR photos.

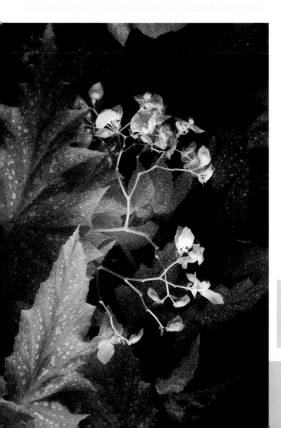

The grain, contrast, and special lighting effects in this photo come from working with an IR (infrared) converted camera. This image has been colorized in software with a soft shade of blue.

The other way to record infrared light is to use your normal digital camera with a filter placed over the lens. These special IR filters are available in ranges that produce varying degrees of effect, and can be found in most camera stores or online. They function by blocking a prescribed portion of visible wavelengths, while allowing IR wavelengths to pass through the lens to strike the sensor.

This method is not as effective as working with an IR-converted camera, and some existing camera models will yield better results than others. You can check a camera's sensitivity to IR by pointing a TV remote at the camera and seeing if you can record the point of light from the control's beam. If so, use the filters mentioned in the Tools section for varying degrees of IR effect.

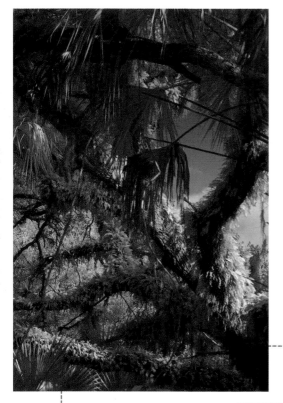

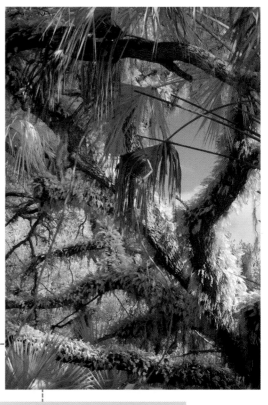

*Exposure Mode:* Manual
*Aperture:* f/9.5
*Shutter Speed:* 1/60 second
*ISO:* 200
*Metering:* Multi-segment
*White Balance:* Auto

The color in the left photo is obvious evidence that the image was recorded using the camera's RGB mode. A red filter was used, which blocks a smaller range of visible light than a darker IR filter. You can choose to convert the color file to monochrome using image-processing software in the computer, emulating the look of true IR black-and-white film.

The IR image below was recorded using a conventional D-SLR in Monochrome mode with an R72 infrared filter placed on the lens. Dark IR filters on a D-SLR produce "purer" IR effects than lighter-colored red filters. But since dark filters block your view through the lens, you must compose and focus before placing one in front your camera. While red filters usually allow for handheld shooting, the more opaque filters require a tripod—not only for the sake of composition, but also because darker IR filters require substantially longer shutter speeds.

Use the image playback to review exposure immediately after recording. You can learn how the look of the image on the LCD will translate as an IR photo after downloading and processing. I have found that flat exposures, lacking contrast when viewed on the LCD during playback, were easier to work with during the image processing portion of the workflow. Too much contrast and exposure in the original recording made for difficult processing. Slight underexposure helped control highlights.

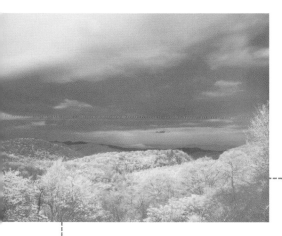
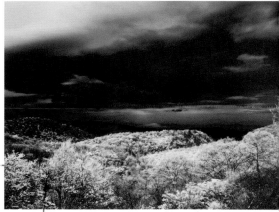

Photo © Kevin Kopp

*Exposure Mode:* Manual
*Aperture:* f/8.0
*Shutter Speed:* 10 seconds
*ISO:* 100
*Metering:* Multi-segment
*White Balance:* Auto
Image processing to enhance
  original photo

**did u know?**
IR allows for many interpretations that can be achieved in the computer after recording the image—from a glowing, ethereal shimmer to dramatic high contrast. In general, these images start out as somewhat soft and flat, but that makes them ideal for processing and enhancement later.

# 3.8 Enhancing Landscapes
## with Your Built-in Flash

## Tools:

- Built-in (on-camera) flash
- Center-weighted Averaging metering
- Spot metering
- Exposure compensation
- Flash exposure compensation

**The small flash** found on your camera is not really intended to illuminate at great distances or to provide strong light into a scene. It is best used for fairly close shooting, helping to balance the contrast between a bright background and a subject that stands in shade, or sometimes to lend just that needed "kicker" of extra light to a scene.

Since the built-in flash is a fixed directional light, it is not as useful for subtle lighting techniques as a shoe-mounted external flash (see section 3.9), which can usually be

turned and tilted to point in a desired direction, or, better yet, can be placed off-camera to illuminate the subject with great precision.

This sunflower was photographed in hard mid day sunlight (below). The result is a washed-out sky, dark shadows that obscure the interior of the blossom, and a generally unappealing look. The image was significantly improved by making an exposure reading for the brighter areas in the scene, and using fill flash. Note how the color and details contribute to a much more pleasing picture (opposite).

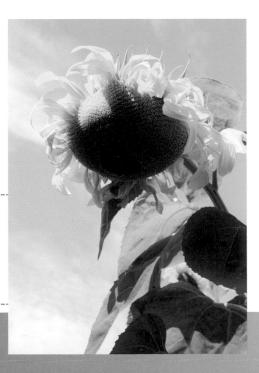

*Exposure Mode:* Aperture Priority
*Aperture:* f/16
*Shutter Speed:* 1/125 second
*ISO:* 100
*Metering:* Multi-segment (Evaluative/Pattern)
*White Balance:* Daylight

*Exposure Mode:* Aperture Priority
*Aperture:* f/22
*Shutter Speed:* 1/160 second
*ISO:* 100
*Metering:* Center-weighted Averaging
   pointed at sky and recomposed
*White Balance:* Daylight
*Flash Exposure Compensation:* −1.5EV

The chief use of built-in flash is to over-
come contrast problems. It can work to
balance light for a more pleasing exposure
in high-contrast conditions.

One advantage of the built-in flash, which might seem a disadvantage at first, is its relatively low power output. This allows you to light something close without affecting the lighting and exposure of more distant subjects. For instance, you might distinguish a foreground subject from a busy and similarly lit (same brightness level) background. Using light in this way to create dimensionality is an excellent technique when the main subject and background need more separation than can be provided by depth-of-field methods alone.

Both the green and white plant and the stream in the photo (below) were in light of the same brightness level. The trick was to feature the plant by slightly underexposing the ambient (natural) light to darken the background, while controlling the output of the camera's built-in flash to fill and brighten the foreground. I further limited the flash effect by setting a narrow aperture and using a moderate telephoto focal length.

There are a number of interesting possibilities when using flash for outdoor photos. In the photo to the right, I made a spot meter reading on the sky, which was considerably brighter than the ground. This caused the ground area to be quite dark. The built-in flash was activated and set at 1EV so it would not overwhelm the foreground shrub and cactus. I also added warmth to the image by setting white balance to Cloudy. You can see how the flash coverage fell off (could not illuminate) at the area right behind illuminated shrubs, resulting in a few details peaking out of a dark area.

*Exposure Mode:* Aperture Priority
*Aperture:* f/16
*Shutter Speed:* 1/30 second
*ISO:* 100
*Metering:* Center-weighted Averaging
*White Balance:* Shade
*Focal Length:* 100mm on full 35mm size sensor
*Exposure Compensation:* –2EV
*Built-in Flash*: Fired
*Flash Exposure Compensation:* –1EV

Be aware that working close to your subject with flash can cause overexposure if you rely completely on the camera's automated exposure system. It's a good idea to make test shots and review them in the LCD. Use the camera's exposure compensation control as well as flash exposure compensation when necessary to reduce the output and record well-lit flash photos.

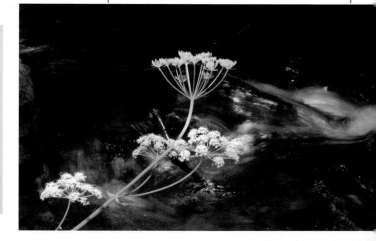

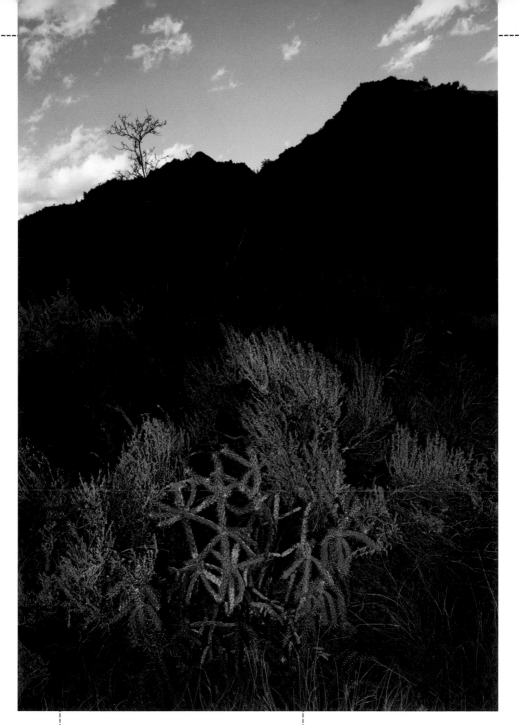

*Exposure Mode:* Aperture Priority
*Aperture:* f/16
*Shutter Speed:* 1/60 second
*ISO:* 100
*Metering:* Spot
*White Balance:* Cloudy
*Flash Exposure Compensation:* −1EV

# 3.9 The Options and Advantages
## of Using External Flash Outdoors

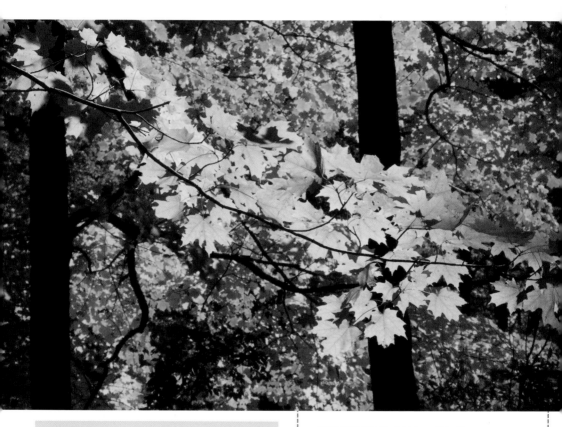

**did u know?**

Flash photography is not only for shooting indoors. There are numerous opportunities when recording landscapes, especially more close-up or detailed photos, to add another dimension by filling darker areas with illumination from an external flash.

*Exposure Mode:* Aperture Priority
*Aperture:* f/8
*Shutter Speed:* 1/125 second
*ISO:* 100
*Metering:* Center-weighted Averaging
*White Balance:* Cloudy
*Focal Length:* 192mm equivalent focal length
*Exposure Compensation:* –1EV
*Flash Exposure Compensation:* –1EV

# Tools:

- Hot-shoe mount flash
- Wireless remote flash system
- Center-weighted Averaging and/or Spot metering
- Exposure lock
- Exposure and flash exposure compensation
- Depth-of-field preview

**Your built-in flash** can be used to deliver small amounts of light, but nothing beats the facility and options offered by a shoe-mount (external) flash. Not only does an external flash offer more power and coverage distance, it can usually be tilted in different directions while mounted on the camera, or even taken off-camera for unique lighting effects. You can control output by using an electronic flash that is dedicated, or synced, to the exposure and focusing systems of your camera.

In this fall foliage scene, the green bough hung about 20 feet away, approximately halfway between the background foliage and the camera. I wanted to enhance the color contrast while flattening the distance between the green leaves and the colored mass behind them. I chose a focal length long enough to compress the space, and an aperture wide enough to produce a sharp foreground differentiated with a slightly blurred background. I checked this sharpness effect by using my depth-of-field preview.

To take my set-up a step further, I made an exposure reading from both the foreground and background areas using a center-weighted averaging pattern in Aperture Priority mode, finding that the light levels on the foreground and background were essentially the same. I then set exposure compensation to –1EV. This darkened the entire exposure, but I wanted to make the foreground leaves stand out even more, and additional light on that portion of the scene was the way to do it. I was too far away for the built-in flash to provide enough "throw," so I activated my external flash. I discovered I had to use a –1EV flash exposure compensation with this stronger unit to diminish the flash "look" in the scene.

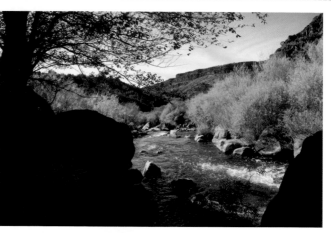

*Exposure Mode:* Manual
*Aperture:* f/22
*Shutter Speed:* 1/125 second
*ISO:* 100
*Metering:* Spot
*White Balance:* Cloudy
*Exposure Compensation:* +0.5EV

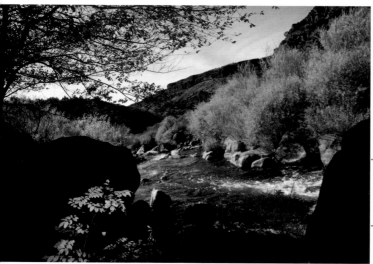

The interplay of shadow and highlight is an essential compositional element that creates a strong sense of depth in a scene. Adding a surprising foreground element with flash can enhance that depth further.

*Flash Exposure Compensation:* –2EV

This shady area provided an interesting frame for this fall river photo. For the first exposure (top), I took a spot reading of the bright orange foliage and added +0.5EV to maintain a bright feeling on the trees while still holding some shadow detail in the stream and surrounding hills. I locked the settings in Manual exposure mode and composed.

I had noticed in front of the rocks a small, yellow plant that had fallen into deep shadow as a result of the exposure being locked on the bright foliage. I mounted a flash and rotated the head to the side so that it only illuminated the plant and not the rocks, then recorded a few exposures with varying degrees of flash exposure compensation based on the original spot meter reading. I wanted to insure flash was just powerful enough to illuminate the plant but not the rock behind it. I also adjusted the tilt angle. The best result was at –2EV flash exposure compensation, which, combined with the narrow aperture, limited the coverage of the flash (lower photo).

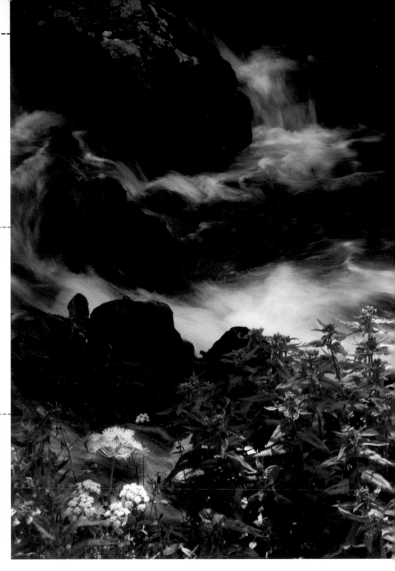

*Exposure Mode:* Shutter Priority
*Aperture:* f/5.6
*Shutter Speed:* 1/15 second
*ISO:* 100
*Metering:* Center-weighted
  Averaging
*White Balance:* Auto
*Exposure Compensation:*
  −1.5EV
*Flash Exposure Compensation:*
  −1.5EV

Wireless flash offers a great deal of lighting flexibility. It frees you from using direct illumination coming only from a location tied to the position of your camera.

A wireless flash system allows you to trigger an external unit that is not directly attached to your camera, but is connected via an infrared or radio signal. You can use a wireless setup to bring a more pleasing light into the scene from the side or above the subject or, as seen in the photo of the stream (above), to create a spotlight effect, having the light illuminate small portions within the frame.

The wireless setup requires a transmitter and receiver. In some cases, the transmitter sends out a radio signal to a receiver mounted to the remote flash, which then fires that flash when you press the shutter release on the camera. Or it may send an infrared signal, which means there must be a line of sight between the transmitter and receiver. In some systems, you can even use the built-in flash to trigger the remote flash.

# Exposure: The Path to Great Photos

**E**xposure refers to the amount of light that strikes photosensitive material, such as a digital image sensor. The term is also used to describe the process of capturing that light. Exposure is controlled by three factors: (1) Time (or duration of exposure); (2) intensity (the volume of light striking that material at any moment; and (3) the sensitivity of the photosensitive material itself (its ISO setting). The shutter speed determines duration, regulating how long the light will strike the sensor, while the aperture's width controls the amount of light that is allowed to fall on the sensor. You set the ISO depending on how bright or dim the lighting conditions in the scene might be. Balancing these three factors provides proper exposure, based on how you want to interpret the scene in front of you.

Modern exposure systems in digital cameras are extremely sophisticated. These advanced features include multi-segment metering (sometimes known as evaluative or pattern), which uses computer algorithms to help determine the best exposure for the scene; and tone curve compensation, which changes the inherent contrast of an image to match the lighting conditions at hand. In the end, however, your decisions about how to expose a scene, and your understanding of how to use the exposure tools at your disposal, will create images that express your personal vision and feeling about the subjects you photograph.

# 4.1 Center-weighted Averaging
## How to Tame Difficult Lighting Situations

## Tools:

- Center-weighted Averaging metering
- Autoexposure Lock (AEL)
- Manual exposure mode
- Check your camera manual to learn how to make various buttons on your camera act as the AEL button

**Metering means measuring the light** in a scene. You can set your camera to meter using one of several different methods.

Center-weighted averaging (CWA) is a metering pattern that reads light from the entire frame, but calculates exposure by emphasizing (or weighting) an oblong area that encompasses about 60-70% at the center of the frame. It is invaluable for recording mostly sky, sky and ground, and images where the light level varies within the frame.

I like CWA because it forces me to consider the light: where it is coming from; how it is angled; and whether it is even or dappled. In my opinion, CWA is the best way to read light that is directional or irregular throughout the scene. The key is to aim the camera at one

of the brightest parts of the frame without excluding other brightness levels. Then using the autoexposure lock (AEL) button, hold that exposure. AEL insures that the measured exposure will not change, even if you point the camera in another direction. Then you can recompose and shoot.

You can also lock exposure by maintaining slight pressure on the shutter release button before pressing it all the way down to make the exposure. Check your camera's instruction manual for other ways to hold exposure, as this is a key control and you want to make it as easy and accessible as possible.

Note how the light is variable throughout the scene to the right above. Using Aperture Priority exposure mode, I took a multi-segment (evaluative/pattern) meter reading before shooting, which calculated exposure over the entire scene. But that gave me settings of f/11 at 1/125 second, one stop more light than the settings from CWA, with its emphasis on the bright portion of the rocky cliffs. Shooting at the multi-segment settings would have resulted in overexposure of the highlight areas. I ended up using CWA and zoomed in to meter the scene, which produced an optimal balance of light and shadow (far right below).

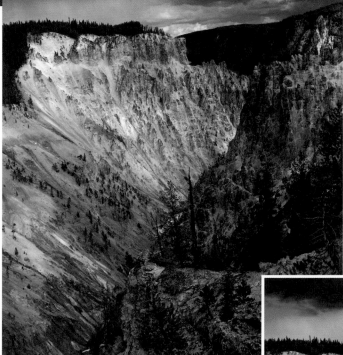

**did u know?**

With a zoom lens, you can zoom in to the area you want to meter (below), pointing the camera at where the light is falling in the scene. Lock expposure with AEL, and then zoom back to recompose as necessary (left).

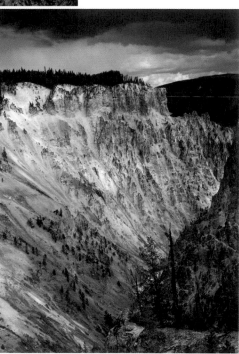

*Exposure Mode:* Shutter Priority
*Aperture:* f/16
*Shutter Speed:* 1/125 second
*ISO:* 125
*Metering:* Center-weighted Averaging
*White Balance:* Daylight

Tip **An alternative to using AEL with one of the automatic exposure modes (Aperture Priority, Shutter Priority, or Program) is to make a reading in Manual exposure mode. You can then shoot without the need to lock exposure.**

*Exposure Mode:* Manual
*Aperture:* f/16
*Shutter Speed:* 1/160 second
*ISO:* 100
*Metering:* Center-weighted Averaging
*White Balance:* Auto
*AEL:* pointed at bright area in center of frame

I zoomed in to lock exposure on the light-toned rock in the center of the frame (left). CWA still incorporated some of the shadow areas in the meter reading from the cliff behind the rock. I then zoomed out to recompose the shot, including the sky in the background (above).

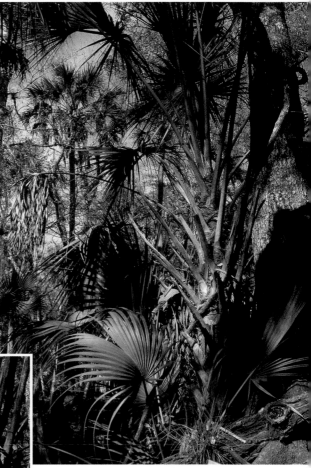

*Exposure Mode:* Aperture Priority
*Aperture:* f/11
*Shutter Speed:* 1/160 second
*ISO:* 100
*Metering:* Center-weighted Averaging
*White Balance:* Daylight

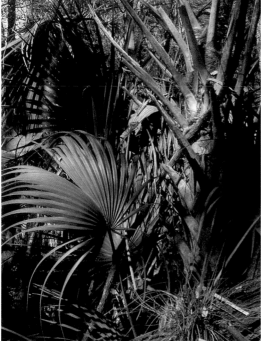

An uneven mixture of light and shadow can be difficult to meter correctly. In this case, the area chosen for the reading (left) has more highlight areas than the final composition (above). In such circumstances, CWA results in a well-balanced exposure that controls highlights without making shadows too dark. A multi-segment reading of this scene might well result in overexposed highlights.

# 4.2 Control Color Intensity
## with Spot Metering

## Tools:

- Spot metering (any exposure mode)
- Exposure compensation
- Autoexposure lock (AEL)

**A spot meter reads only a small** area (about 2–5%) in the center of the frame. It is like a fine brush that can paint with light in a way that no other exposure metering pattern can deliver. Aim it at any color in the scene and use the AEL button before recomposing as necessary. The exposure system will expose properly for that tone, meaning that bright colors will become darker and more vivid. It also insures that no bright area within the frame will become overexposed, while producing deep, sonorous shadows as compositional counterpoints.

There are times when the spot meter needs to be used with exposure compensation. A picture may well become underexposed if you spot meter only on a bright area and fail to compensate exposure. The white area will become gray, and the rest of the values will become overly dark. Add +1EV or more, and that white area will increase brightness by a stop, placing it properly within the range of recorded tones.

Slot canyons and other tight places become interesting when the light plays in and around bends, but the danger is always overexposure of bright areas. Making a spot reading of the bright area (and filling the shadows with flash if necessary) insures that those important colors will be well exposed.

In the lower photo to the right, note how the bright light caused reflective fill in the shadow areas, so no flash was required.

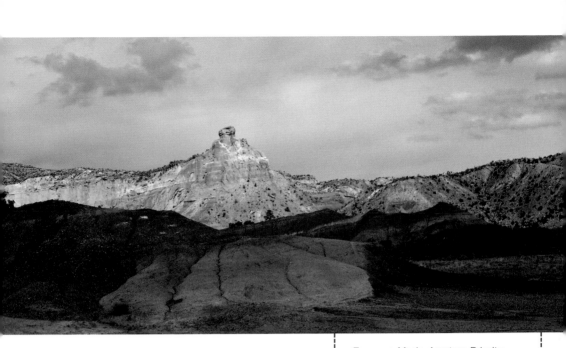

*Exposure Mode:* Aperture Priority
*Aperture:* f/11
*Shutter Speed:* 1/160 second
*ISO:* 100
*Metering:* Spot reading on bright hill
*White Balance:* Daylight

Spot was the only practical metering choice under these conditions above, with the sun moving in and out of the clouds, especially at this distance. The reading on the lit area of the hills provided a very good exposure. The dark shadow areas accentuate the glorious light on the hills.

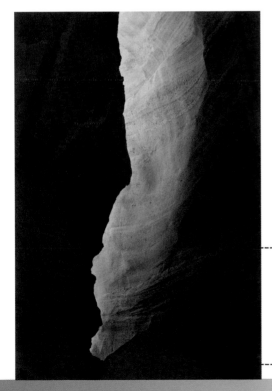

*Exposure Mode:* Aperture Priority
*Aperture:* f/16
*Shutter Speed:* 1/250 second
*ISO:* 200
*Metering:* Spot reading on brightest area
*White Balance:* Auto

# 4.3 Adjust Exposure
## to Get It Right

## Tools:

- Playback mode on LCD
- Histogram
- Highlight warning

Optimal exposure of the bright areas in this waterfall is critical to the image's success. If the water's highlights are overexposed, a print of the image will lack texture in the most vital portions of the scene. The black areas below simulate highlight warnings that indicate a need for less exposure. The picture to the right shows the result from decreased aperture and exposure compensation settings.

**The playback function** in your digital camera's LCD will clearly show a photo's composition and allow you to check its sharpness by enlarging the image. But verifying exposure can be a different matter. An image that looks fine on the LCD might actually be poorly exposed, and sometimes images that don't look so good might end up being OK when you view them as a print or on a computer screen.

Most often there is little to be concerned about if the image looks a bit dark during playback, because making the image lighter during image processing is usually a simple matter. But curing overexposed areas in a digital image file is more difficult. Although the ability to adjust the exposure of a RAW file can mitigate this problem somewhat, there will be no highlight recovery if usable digital data has not been recorded in areas that have been struck by too much light.

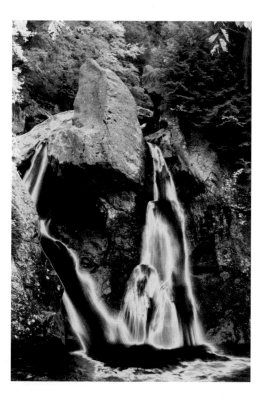

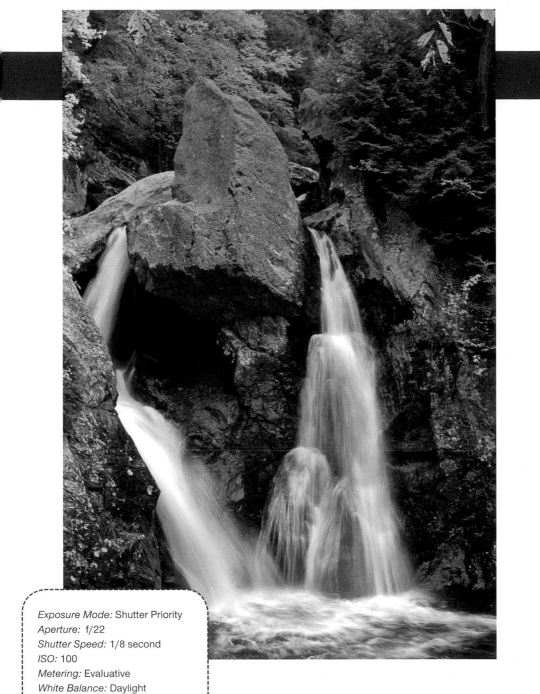

*Exposure Mode:* Shutter Priority
*Aperture:* f/22
*Shutter Speed:* 1/8 second
*ISO:* 100
*Metering:* Evaluative
*White Balance:* Daylight
*Exposure Compensation:* −1.5EV

You have two aids to objectively check exposure in the LCD—the histogram and the highlight warning. My preference is to go with the highlight warning, as illustrated on the previous page, which blinks within the areas of overexposure when you review the image in playback. You often set this by pressing the Info button during playback (or a similar control—check your camera's instruction manual).

It is OK if you notice small areas of overexposure blinking in the highlight warning, especially if they merely represent sparkling glints of light (spectral). But if a large area or important portion of the subject is overexposed, your best course is to decrease exposure. You can do this by taking a center-weighted averaging reading that includes the brighter areas in the scene, then locking exposure. Another way is to set minus exposure compensation, or by switching to Manual exposure mode and increasing the shutter speed and/or narrowing the aperture until you get rid of those "blinkies."

*Exposure Mode:* Aperture Priority
*Aperture:* f/13
*Shutter Speed:* 1/80 second
*ISO:* 400
*Metering:* Evaluative
*White Balance:* Daylight

The histogram for this image shows a large spike of light tones that terminates abruptly against the highlight edge, indicating areas too bright for the sensor's dynamic range to record. The sky and the mountains in the background are overexposed and lacking detail.

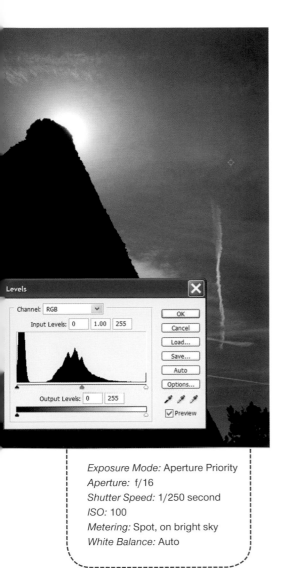

*Exposure Mode:* Aperture Priority
*Aperture:* f/16
*Shutter Speed:* 1/250 second
*ISO:* 100
*Metering:* Spot, on bright sky
*White Balance:* Auto

In my opinion, the histogram is less instinctive and less instructional. It is a graph that shows the distribution of brightness values in the scene. It can be helpful to indicate poor exposure if large gaps of no data show in the graph, or if the data is stacked and truncated against the left (underexposed) or right (overexposed) axis.

But there are times when the histogram can lead you to a wrong conclusion. An image does not always need to demonstrate the full gamut of tones (a bell curve shape) to be an effective or appealing photograph. A "good" exposure is one that best expresses the mood and lighting you want to show in a scene. The rock formation at left is silhouetted against the sun, which just peaks out from the top. The histogram shows a large, underexposed area with no detail in the shadow areas. But that doesn't mean a mistake in exposure—that's how I wanted the scene to look!

# 4.4 Exposing to Capture
## The Beauty of Flowing Water

## Tools:

- Shutter Priority exposure mode
- Tripod
- Cable or remote shutter release (or self-timer release)
- Neutral density or polarizing filter
- ISO sensitivity

**Anything that moves in front** of your camera while the shutter is open will reveal motion. The key is determining how that will be rendered, which depends on two factors: (1) The length of time the shutter remains open, and (2) the velocity of the moving object.

One of the more pleasing ways to use shutter speed in landscape photography is to record the flowing motion of water, whether in rivers, streams, or as ocean waves. Showing motion with a still photo is intriguing, and water captured as a smooth flow becomes idealized, opening the imagination to the complex physics of the world.

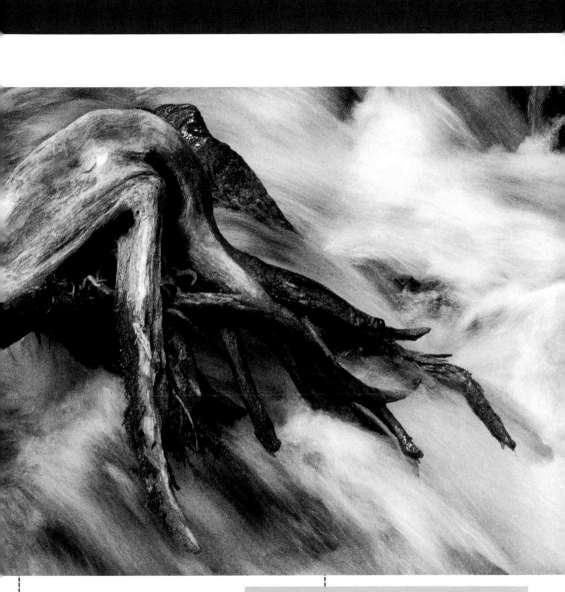

*Exposure Mode:* Shutter Priority

*Aperture:* f/11

*Shutter Speed:* 0.5 second

*ISO:* 100

*Metering:* Center-weighted Averaging

*White Balance:* Auto

*Filter:* 4X ND, made in Monochrome with
   additional orange filter effect

**did u know?**

Faster subject movement and slower shutter speeds produce the most dramatic effect on moving water. If you are close to the effect you want, but find the image slightly overexposed, use RAW format to give a 1 to 1.5-stop allowance that you can correct later in processing.

There is no prescribed shutter speed that will accomplish this effect for every shot, although 1/15 second is a good starting point. Set your speed slightly faster or slower, depending on how silky you want the water to look. The angle at which you photograph will also have a profound effect on appearance. Shooting at a right angle (perpendicular to the subject) will enhance the motion; shooting at less than a right angle (more head-on) will require a slower shutter speed to get a similar effect.

Shooting at shutter speeds this slow means that handholding will inevitably cause camera shake. It is necessary to mount the camera on a tripod or other steadying device. While image stabilized lenses can help, they simply might not always do the job when shutter speeds are this slow. (Of course, if shooting near the edge of the water or in it, make sure the tripod is rock solid. I speak from experience.)

To further avoid any camera movement, use the self-timer drive setting to delay firing the shutter for a couple of seconds, or, better yet, use a cable release or remote shutter release accessory. These are usually available from your camera manufacturer.

## Smooth Flowing Water

The main challenge to recording this type of soft-looking flow is bright natural light. You might not be able to get the shutter speed as slow as you like without overexposing the scene. You can try several techniques to manage this situation:

- Lower the ISO (light sensitivity) to the lowest setting on the camera

- If the scene is very bright, you might be unable to set the aperture narrow enough at your desired shutter speed. Even at f/16 or f/22, you might only get a reading of 1/60 second or faster, which would be too fast to attain this effect. If this is the situation, you can:

    a. Find a shady spot where the light level is lower

    b. Place a light reducing filter over the lens, such as an ND (neutral density) filter, which can help lower light levels without changing color. ND filters comein strengths that are expressed with numbers such as 2X (1 stop of light), 4X (2 stops of light), and so forth.

    c. You can also use a polarizing filter, which generally drops light transmission by about 1.5 stops.

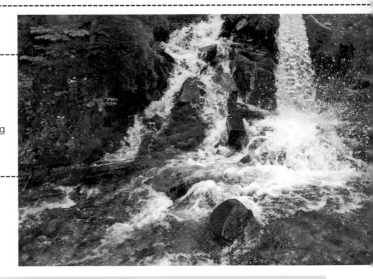

*Exposure Mode:* Shutter Priority
*Aperture:* f/4
*Shutter Speed:* 1/250 second
*ISO:* 100
*Metering:* Center-weighted Averaging
*White Balance:* Auto
*Tripod*

Experiment with various shutter speeds. Fast shutter speeds are for those times when you want to show the splashes and stop the motion (above), while slower shutter speeds make the flow look like a wrapping of silk sheets. Below, since I could not narrow the aperture any further (f/22), an ND filter was added to expose at an even slower shutter speed than normal for these conditions.

*Exposure Mode:* Shutter Priority
*Aperture:* f/22
*Shutter Speed:* 1/4 second
*ISO:* 100
*Metering:* Center-weighted Averaging
*White Balance:* Auto
*Tripod*
*Filter:* 2X ND used to block an additional
  stop of light

# Lenses & the Visual Aspects
# of Digital Photography

**T**he lens is your eye on the imaging world, gathering light and focusing it onto the sensor of your digital camera. Lenses are vitally important in serving the creative aspects of your photographic work, because they can bring distant objects closer, expand your field of view, or get closer to subjects than you ever would with your unaided eye. You can use lens settings to make images that differentiate between objects within the same frame by making some sharp and others unsharp, or to create sharpness throughout the scene from a few feet to infinity. You can also work with lenses of various focal lengths to create visual relationships that appear to stack distant subjects atop one another, or that make close subjects seem exaggerated in the context of the entire scene. The lens, and how you use it, has a lot to do with portraying the way you see the world—with conveying your point of view.

# 5.1 Various Focal Lengths
## Lead to Interesting Points of View

**Depending on the type of camera** you have, you are likely to possess a zoom lens or several interchangeable lenses. There are a number of considerations when choosing a focal length or a particular lens for a shot. Each different focal length setting can influence how you decide to shoot that scene and, importantly, affect the way you perceive the potential image. There are no set rules; with experience you will gain an instinct as to which lenses match the landscape in which you are photographing.

One way to sort lenses is by the angle of view they provide. Picture yourself standing still and looking at a landscape scene. You might think of the angle of view of as an arc or cylindrical cone extending outward from your eyes into the scene. You can imagine that cone expanding to take a higher or wider view, or perhaps contracting, to give a narrower or more tunnel-like view. These scenarios might illustrate the differences in views between normal, wide-angle, and telephoto focal lengths.

## Tools:

- Lenses with various focal lengths in 35mm equivalents
- Super wide-angle: 12 (or less)–24mm
- Long or Super telephoto: 400mm+
- Wide-angle: 24–40mm
- Normal: 40–70mm
- Moderate telephoto: 70–150mm
- Telephoto: 200–400mm

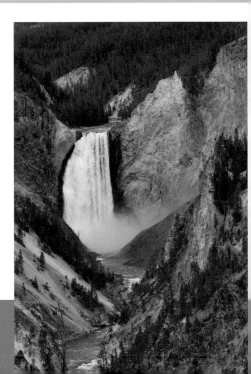

*Exposure Mode:* Aperture Priority
*Aperture:* f/16
*Shutter Speed:* 1/60 second
*ISO:* 100
*Metering:* Center weighted
*White Balance:* Daylight
*Focal length:* 28mm equivalent focal length

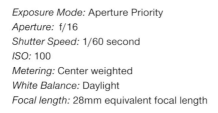

*Exposure Mode:* Aperture Priority
*Aperture:* f/8
*Shutter Speed:* 1/500 second
*ISO:* 200
*Metering:* Center weighted
*White Balance:* Daylight
*Focal Length:* 400mm equivalent focal length

Wide view or telephoto effect, every lens offers a distinctive view that has a profound effect on composition. Both of these photos were taken from the same location at Artist Point in Yellowstone National Park. The dramatic differences between them are due to the different focal lengths used to record each image.

The focal length of the lens, expressed in millimeters, is the distance from the rear element of the lens to the sensor plane. Practically, it helps categorize lenses by their angle of view, with lower numbers providing a wider view (see the tool box).

• **A super wide-angle** of view is beyond your peripheral vision, and the image may have an almost surreal look and distorted edges. It can produce foreshortening effects where close subjects seem enlarged beyond their true scale.

• **Wide-angle** encompasses a view that is slightly larger than normal peripheral vision, but with much less (or no) distortion compared to super wide.

• **Normal** views show what your unaided eyes would see, displaying no distortion.

• **Moderate telephoto** angles of view will show slight distortions of the spatial relationships between subjects, with a small degree of tunnel vision.

• **Telephoto to super telephoto** angles of view will exhibit distinct tunnel vision, and make distant objects appear closer together than they really are (stacked, or compressed).

## 35mm Equivalent Focal Lengths

Note that the distinctions between the focal length categories are somewhat loose. That's because there are a number of different sensor sizes found in the various digital cameras, which result in an interesting effect: A very wide lens on one camera might not be so wide on another. The image the lens projects on the sensor becomes cropped if one sensor is smaller than another. Think of a cone of light being cut at different distances from its peak.

To find the equivalent (sometimes called effective) focal length of a particular lens on your camera, you usually have to multiply the focal length by a certain factor—a factor that depends on the size of the sensor.

Understanding the relationship between different focal lengths and various sensor sizes can become confusing. To simplify the issue, photographers use the "35 millimeter equivalent" as a way of describing lenses on digital cameras in terms of what their equivalent focal length would be if used on a 35mm camera. For example, if you have a 16mm lens on your digital camera, and its smaller-than-35mm sensor requires a 1.5 multiplication factor, the lens would deliver an image with the same angle of view as if it were made using a 24mm lens on a camera with a 35mm-size sensor (16 x 1.5 = 24).

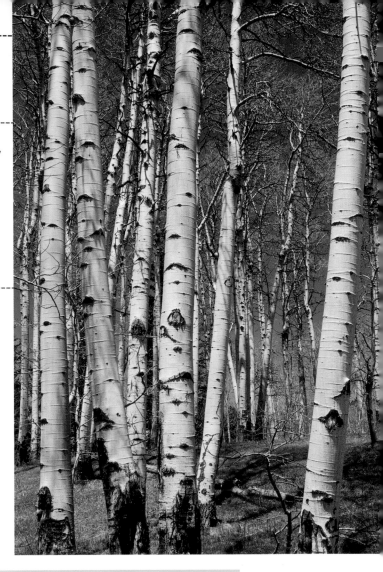

*Exposure Mode:* Aperture Priority

*Aperture:* f/16

*Shutter Speed:* 1/125 second

*ISO:* 100

*Metering:* Multi-segment
 (Evaluative/Pattern)

*White Balance:* Daylight

*Focal Length:* 60mm equivalent
 focal length

Sometimes a normal view, with absolutely no optical distortions, is just what the scene calls for.

Some of the different multiplication factors are: 2x for 4/3 and Micro 4/3 cameras, 1.5x for Nikon DX, and 1.6x for most Canon D-SLRs. FX, or full-frame cameras, where the sensor is the same size as a 35mm film frame, have no multiplication factor.

Talking about focal lengths as 35mm equivalents provides a baseline for comparison, without having to know sensor sizes or go through time-consuming multiplying. Throughout this book, you'll see that all of the focal lengths are described as 35mm equivalents unless stated otherwise.

# 5

## 5.2 Learning Lens Characteristics
### Lets You Make Creative Adjustments

## Tools:

- Lenses of various focal lengths
- Macro lenses
- Fast lenses (wide maximum aperture)
- Image stabilized lenses

**In addition to focal length,** there are a number of characteristics common to lenses that are good to understand. Knowing how to use your lens effectively can help you make photos that stand out from the ordinary.

One important characteristic of any lens is its minimum focusing distance; in other words, how close you can get to a subject and still focus sharply on it. This changes from lens to lens. In particular, some telephoto lenses cannot focus as close as wider-angle lenses, although their ability to bring distant subjects closer might compensate somewhat for this. If you really want to get close to a subject, there are specially made macro lenses that allow you to photograph within inches.

Another lens characteristic concerns the maximum aperture, which is the widest opening the lens diaphragm allows. This will tell you how much leeway you have when you need to record in low light or want to set fast shutter speeds. It also controls how shallow your depth of field can be if you want to create images with soft backgrounds.

Lenses with a wide maximum aperture are known as "fast lenses" because they allow you to set faster shutter speeds. This is helpful to reduce camera shake for handheld shots, especially in the telephoto focal length range. The cloud cover and ocean reflections in the seaside photo (lower right) produced just enough light for a handheld exposure, but to catch the waves in motion I had to work with a fairly fast shutter speed. My lens gave me the ability to open the aperture to the point where I could set a shutter speed fast enough to stop the action of the moving waves. Note that I did some dodging on the water area when processing the image to add some sparkle to the froth.

*Exposure Mode:* Aperture Priority
*Aperture:* f/16
*Shutter Speed:* 1/250 second
*ISO:* 100
*Metering:* Center weighted
*White Balance:* Auto
*Lens:* 60mm macro lens, with camera on tripod, focused from five inches away

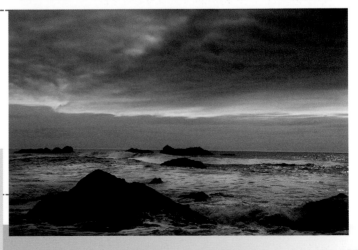

*Exposure Mode:* Aperture Priority
*Aperture:* f/4
*Shutter Speed:* 1/250 second
*ISO:* 100
*Metering:* Center weighted
*White Balance:* Daylight
*Focal Length:* 28mm

The maximum aperture on the lens used here is f/2.8. Because of optical distortion issues with most lenses, I suggest shooting at least one stop less than the maximum aperture for best quality. Of course, if you need that extra stop, then use it.

Some lenses are made with an image stabilization system built into them. These lenses can always help reduce camera movement, but you have to decide for yourself how much the added cost will enhance your ability to take photos at slower shutter speeds. This type of stabilization can be especially helpful when shooting handheld in low light or with a long telephoto focal length, and can also steady images when the platform from which you shoot is not exactly stable, such as a boat or helicopter.

You can use the proper lens to enhance stacking (making things appear closer to each other than they really are) or foreshortening (exaggerating the size of foreground subjects in relationship to the background). Telephoto focal lengths produce a compression effect, shortening the apparent distances between subjects. Using a wide-angle lens to work very closely will enhance the size of a subject so it appears larger relative to objects in the background.

The trees in this grove appear quite close together, although the area covered is about 40 yards (12 meters) deep. Taken from a distance with a long focal length, this image shows the effects of stacking and compression.

*Exposure Mode:* Shutter Priority
*Aperture:* f/8
*Shutter Speed:* 1/500 second
*ISO:* 200
*Metering:* Multi-segment (Evaluative/Pattern)
*White Balance:* Daylight
*Focal Length:* 400mm

*Exposure Mode:* Aperture Priority
*Aperture:* f/22
*Shutter Speed:* 1/60 second
*ISO:* 100
*Metering:* Multi-segment (Evaluative/Pattern)
*White Balance:* Daylight

You can enhance or exaggerate lens effects by shooting at odd angles and using unusual points of view. Both of these photos were made with a 24mm equivalent focal length—the horizontal shot was made "straight ahead" with care in making sure the horizon line (the top edge of the grass) was parallel to the frame edge. The vertical was shot with the camera tilted up while I leaned back to distort the slightly curved edges of the lens.

*Exposure Mode:* Aperture Priority
*Aperture:* f/22
*Shutter Speed:* 1/125 second
*ISO:* 100
*Metering:* Center weighted
*White Balance:* Daylight
*Focal Length:* 24mm positioned 12 inches
(30.5 cm) from front tree

### did u know?

Foreshortening can be created by positioning a wide-angle lens close to the foreground subject and setting a narrow f/stop to create sharpness throughout the image space. Use the depth-of-field preview to make sure all of the closest areas are focused to your satisfaction.

# 5.3 Capture Eye-catching Detail
## with Close-up Photography

**There is an intricate and fascinating** world awaiting your discovery; one found by getting close enough with your camera to make an intimate inspection of your subject. This is the world of close-up photography. While some of the lenses you own may allow you to focus fairly closely to an object, the most exciting work can be done with special accessories, including macro lenses, that allow you to get closer to a subject than is possible with normal lenses.

## Tools:

- Close-up (macro) lens
- Extension tubes or close-up lens accessories
- Aperture Priority mode
- Closest subject focus priority
- Depth-of-field preview
- Live View
- Tripod

Macro lenses are built for close focusing, although you can also use them for working at normal distances. The focusing distance is close enough so that the size of the subject in life is the same as the size reproduced on the sensor. Some zoom telephoto lenses have a close-up mode that allows you to get closer than normal. You can also use add-on lens accessories, such as extension tubes that mount between the lens and body, extending the close-focusing ability of nearly any lens to within inches. Additional close-up lens accessories are available, which are essentially magnifying glasses that fit over the lens by screwing into the filter threads.

The advantage of using a macro lens with a long focal length (80mm and up) for close-ups is that you can focus in close and not be on top of the subject. This avoids the problems of scaring skittish insects and casting the camera's shadow over your subject. It also increases your distance to allow for more flexible composition. The disadvantage of close-up work when using longer lenses is that you will have less margin for error in terms of sharpness, because longer focal lengths produce shallower depths of field than shorter ones, like 50mm macro lenses or wide-angle close-up lenses.

*Exposure Mode:* Aperture Priority

*Aperture:* f/16

*Shutter Speed:* 1/30

*ISO:* 320

*Metering:* Center-weighted Averaging

*White Balance:* Shade

*Lens:* 25mm macro that can focus as close as four inches

*In-camera image stabilization:* Activated

### did u know?

Live View with articulated LCDs, especially when combined with in-camera image stabilization, are a boon to close-up work because there are times you simply cannot use a tripod for a close-up photo. For this shot, which would have meant lying in the cold mud to look through the viewfinder, Live View enabled me to lower the camera close to the surface of this frozen pond without getting wet and muddy.

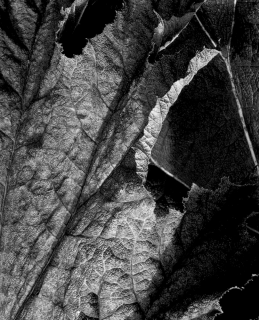

*Exposure Mode:* Aperture Priority
*Aperture:* f/16
*Shutter Speed:* 1/30
*ISO:* 320
*Metering:* Center-weighted Averaging
*White Balance:* Daylight

Using a 50mm macro lens for this close-up, a narrow f/stop was used to lengthen depth of field, and the focus point was set on the bright fold to the right-center of the leaf.

In addition to using special lenses and equipment, there are a number of photographic techniques that will help your close-up work. For one thing, compose so that there are no large areas of unsharpness in the foreground, which often disturb the view. Use an f/stop at least one to two stops narrower than the widest possible aperture. Depth of field sharpness begins a bit in front of the point of focus, so having the lens stopped down from maximum aperture helps bring more of the foreground into sharpness. On the other hand, you might want to keep background elements from intruding, so don't stop down so much that you bring them into distracting sharpness. Use the depth-of-field preview to see if you are set to record the desired image effects.

The depth-of-field preview is an important tool. The camera lets you view scenes through the viewfinder (or via Live View) at the widest aperture on the lens, so that you have the most light possible to compose. But if you are not actually shooting at the widest aperture, the depth of field you see when composing will be shallower than what you will record with the actual "taking" aperture. To see the effect of the taking aperture on the range of sharpness, you must press depth-of-field preview button.

*Exposure Mode:* Manual
*Aperture:* f/11
*Shutter Speed:* 1/30
*ISO:* 200
*Metering:* Multi-segment (Evaluative/Pattern)
*White Balance:* Daylight
*Lens:* 80mm macro lens, photographed from about a foot away

**did u know?**

Stopping down from the lens' maximum aperture will increase depth of field to help insure that all edges and uneven surfaces of a close-up photo are sharp. If that leads to underexposure, try increasing the ISO a little.

Use single AF mode to insure that the subject is in focus. Unless set otherwise, the shutter on most cameras will not fire until focus has been confirmed. Set the AF targets at their widest and have your camera set at closest subject focus priority (generally the camera default). Make sure the AF targets light and confirm on that close area. If you find that focus seems to jump from one area to another, simply switch to manual focus.

If you decide to handhold, use image stabilization (if available) on the camera body or lens, but be aware that even slight changes in subject distance can be critical to sharpness and depth of field considerations. When holding the camera by hand, your subject distance will inevitably change a little, because it is nearly impossible to keep the camera absolutely still. It is a much better idea to work on a tripod if at all possible to compose, since a tripod keeps the camera steady and locks down the camera-to-subject distance. If you must hand hold, move in slightly toward the subject as you are ready to shoot with the depth-of-field preview engaged, and release the shutter the moment you see the image effect (depth of field) you want. This technique usually is best done in manual focus mode.

# 5.4 Producing Sharp Features
## Throughout the Entire Photo

## Tools:

- Aperture Priority mode
- Focus lock
- Tripod when needed to insure sharpness with narrow apertures

**You can easily make photos** that are sharp everywhere within the frame. You do this by creating a deep depth of field with your camera and lens. Depth of field refers to the appearance of sharpness in the area in front of and behind the point where you focus the lens. While there are reasons to sometimes soften backgrounds, a deep depth of field creates a powerful sense of place for landscape subjects. Each element in the picture, whether similar or disparate, is given equal consideration when the depth of field stretches from the front of the image to the very back.

The techniques and tools for producing this type of depth and sharpness within your photo are not difficult to apply:

- Use a wide-angle lens. Depth of field varies inversely with focal length for any given aperture or distance between camera and subject. So, the wider the lens (short focal length), the greater the potential depth of field.
- When using a telephoto lens, be sure to set a narrow aperture and set focus at the closest subject. This will insure that all subjects in the frame are as sharp as possible
- Be sure to focus on a foreground subject, even if you have to move back to do so.
- Use as narrow an aperture as you can, given the lighting conditions. The narrower the aperture, the greater the depth of field for any given focal length and camera to subject distance.
- Use your depth-of-field preview function to check the effect of your aperture settings.

The camera's AF system could have grabbed focus just about anywhere within the frame in the lower photo on the opposite page. To insure that focus started from the lower edge of the frame, I pointed the camera down toward my feet with the center focus point selected, then used AF lock to keep focus at that distance, recomposed, checked my depth-of-field preview to make sure all was sharp, and then shot.

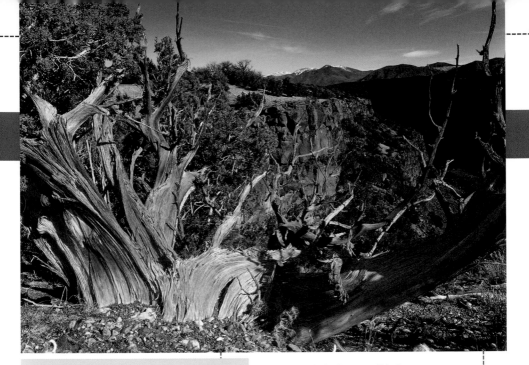

**did u know?**

You can exaggerate the size of foreground subjects in relation to the background by taking advantage of a lens' close focusing ability and using a narrow aperture. This point of view increases the sense of depth, which is in turn enhanced by the sharpness from near to far.

*Exposure Mode:* Aperture Priority
*Aperture:* f/22
*Shutter Speed:* 1/125 second
*ISO:* 200
*Metering:* Center-weighted Averaging
  (reading made from lower left of frame)
*White Balance:* Daylight
*Focal Length:* 24mm

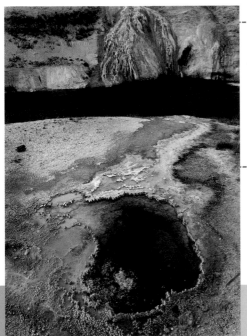

*Exposure Mode:* Aperture Priority
*Aperture:* f/22
*Shutter Speed:* 1/60 second
*ISO:* 200
*Metering:* Multi-segment (Evaluative/Pattern)
*White Balance:* Daylight (converted to black
  and white in software)
*Focal Length:* 50mm

You do not always need a wide-angle lens to create deep depth of field. This photo was made with a 50mm lens set at a narrow aperture, and the AF system set at closest subject priority, about four feet in this case. Sharp focus goes from the foreground rocks to the distant hills.

*Exposure Mode:* Aperture Priority
*Aperture:* f/16
*Shutter Speed:* 1/250 second
*ISO:* 100
*Metering:* Multi-segment (Evaluative/Pattern)
*White Balance:* Daylight
*Focal Length:* 50mm

To insure sharpness throughout the space within a scene, even when shooting at long distances, mount the camera on a tripod and set the aperture to f/11 or smaller (higher f/number). The white-striped ridge and the mountain behind it are at least a half mile distant from one another. The telephoto lens compresses space, and the narrow aperture insures sharpness on both near and far subjects.

*Exposure Mode:* Aperture Priority
*Aperture:* f/16
*Shutter Speed:* 1/125 second
*ISO:* 100
*Metering:* Center-weighted Averaging
*White Balance:* AWB
*Focal Length:* 100mm

Pay attention to where within the frame you want the range of focus to begin when you shoot using a deep depth of field. Specify that point through either manual focus or by applying focus lock with the AF target point lit on the closest subject within the frame.

While a general and large target area may successfully pick up focus much of the time, you should use care in selecting focus points to insure the effectiveness of this technique.

# 5.5 Telephoto Lenses
## Help Bring Your Subject into Focus

**While telephoto lenses** are primarily thought of as tools to get visually closer to distant subjects, they can also be used with wide apertures to produce shallow depth of field, creating out of focus or "painterly" backgrounds. As you consider how to isolate subjects in a crowded scene, or to differentiate a subject from a similar background, keep the following principles in mind:

- Depth of field becomes shallower as the focal length of the lens increases. There fore, at any given focal length or camera-to-subject distance, you can emphasize a subject more clearly against the rest of the scene with telephoto lenses than with shorter focal lengths.

- Depth of field also decreases for any given focal length or aperture as the camera-to-subject distance decreases. In other words, the depth of field gets shallower as you get closer to your subject.

- Depth of field decreases for any given focal length and camera-to-subject distance as the aperture becomes wider.

Combine all three and you can produce a very effective contrast between a sharp subject and its softer surroundings within a scene.

## Tools:
- Telephoto focal length
- Aperture Priority mode

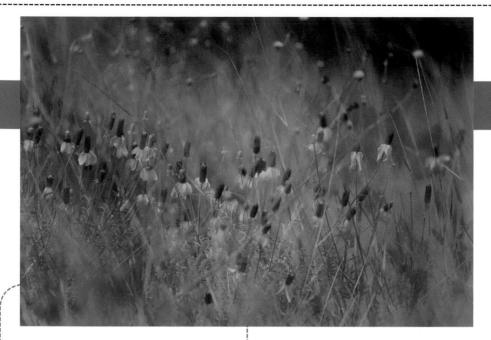

*Exposure Mode:* Aperture Priority
*Aperture:* f/5.6 (maximum opening for this lens and focal length)
*Shutter Speed:* 1/500 second
*ISO:* 200
*Metering:* Center-weighted
*White Balance:* Daylight
*Focal Length:* 200mm

### did u know?

When shooting flowers and other plants, it is helpful to set your shutter speed as high as possible, given how open you want your aperture, to help reduce blur caused by even a slight wind blowing across your subject. The fast shutter speed is also an advantage against camera movement if you must handhold to record your landscape photo.

*Exposure Mode:* Aperture Priority
*Aperture:* f/5.6
*Shutter Speed:* 1/500 second
*ISO:* 400
*Metering:* Center-weighted
*White Balance:* Shady
*Focal Length:* 300mm

In both the photo on the opposite page and the one above, I used long focal lengths with f/stops open to their maximum width to achieve a similar effect— to differentiate the forest from the trees (quite literally, in one case!).

You can see that the point of focus in the forest photo is a cottonwood tree. It stays sharp while the rest of the grove fades into softness. A telephoto focal length will compress space. Here we have a bit of a mixed bag—a tightened sense of distance between subjects due to the telephoto effect, and spatial separation due to a shallow depth of field.

In the wildflower shot, the wide aperture creates a selective focus and a narrow plane of sharpness to differentiate individual flowers from a field filled with similar looking blossoms. Shooting fairly close— about 10 feet (3 meters), which is close to the lens' minimum focusing distance—emphasizes the effect.

# 5.6 Compose Using Focus Lock
## for Precise Depth of Field

**Even if you maximize** the depth of field with a short focal length lens, a narrow aperture, and/or by stepping back from the foreground subject, you may not get everything in the scene as sharp as you want. It is very important to place focus on the right subject, which is usually (though not always) the subject closest to you in the frame. There is some leeway for exact focus placement at narrow apertures, because depth of field begins in the frame at a point slightly in front of the actual focusing distance. But there may be times when objects sitting at the edge of the frame are not captured by you or the autofocusing mechanism.

There are two ways to determine the beginning point of the frame's depth of field, thus insuring that close subjects will be in focus. One is to simply use Manual focus and adjust the lens so that the foreground subject is sharp. You can then activate depth-of-field

## Tools:

- AFL (autofocus lock)
- AF target selection
- AF mode selection (single AF)
- Manual focusing
- Depth-of-field preview

preview to see how far depth of field extends into the scene. Using the preview also allows you to see how far behind the closest subject you can focus and still maintain as much of a range of sharpness as you desire.

The other method is to choose a single AF target point (I tend to use the center point) and aim the camera to place that point on the foremost subject, apply autofocus lock (AFL), and then recompose before shooting. Activating depth-of-field preview helps you determine whether you have all that you want within the range of sharpness.

> **Tip**
>
> When you are setting the point of focus using the AF system, you must "grab" the subject using one of the AF targets in the viewfinder and make sure that focus is confirmed. You then need to lock that point as the focusing distance. Depending on your camera model, this is done by either pressing the AFL button or by maintaining slight pressure on the shutter release button.

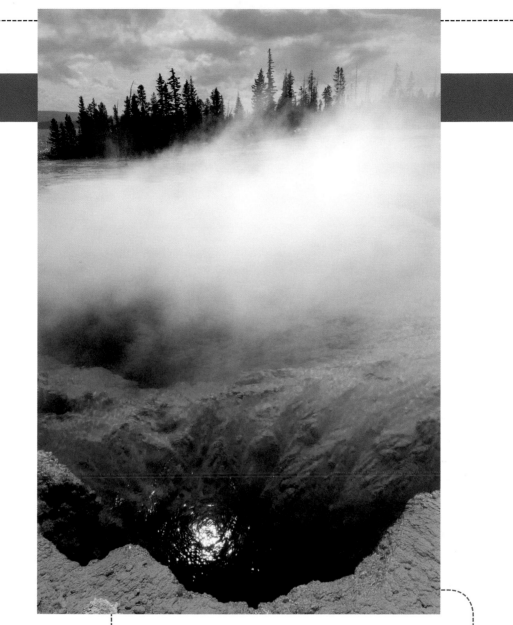

This shot poses numerous problems for any AF setup. The water and mist obscure the contrast that most AF systems depend on to determine focus. In addition, the composition requires that the front edge of the pool be sharp, so it needs an extremely deep depth of field. I set a narrow aperture with a wide-angle focal length and locked focus with the center AF point aimed at the center of the frame.

*Exposure Mode:* Aperture Priority
*Aperture:* f/22
*Shutter Speed:* 1/60 second
*ISO:* 200
*Metering:* Center weighted
*White Balance:* Daylight
*Focal Length:* 24mm

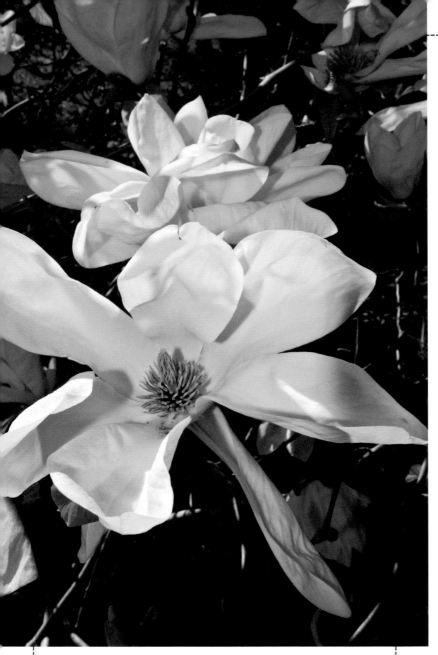

*Exposure Mode:* Aperture Priority
*Aperture:* f/22
*Shutter Speed:* 1/60 second
*ISO:* 100
*Metering:* Center weighted
*White Balance:* Daylight
*Focal Length:* 20mm

When focusing close, the point of focus acquisition is critical. Poor focus on the foremost areas often ruins the shot. For this image, made with a 20mm lens, focus was confirmed and locked on the closest petal, then I recomposed. Shooting at the narrowest aperture on the lens yielded the deepest possible depth of field.

To you and me, the picture above looks like a stand of birch trees in the snow—to the focusing system in a digital camera it looks like a lot of confusing and tempting targets. There are two ways to work here. For one, you can switch to Manual focus and set the aperture according to the image effect you want. Use the depth-of-field preview to analyze the area of acceptable sharpness. Or secondly, you can set the center AF target and place it over the foreground tree until it lights up to confirm focus. Then lock focus, recompose, check the depth-of-field preview, and expose the image.

*Exposure Mode:* Aperture Priority
*Aperture:* f/11
*Shutter Speed:* 1/500 second
*ISO:* 100
*Metering:* Evaluative
*White Balance:* Daylight
*Focal Length:* 20mm

# 5.7 Good Bokeh
## Produces Pleasing Backgrounds

## Tools:

- Aperture Priority mode
- 100-200mm equivalent focal lengths

**Bokeh is about the appearance of** out of focus areas in a photo, usually in the background, and has to do with whether these areas are rendered in a pleasing fashion or not. It is a subjective judgment call for many.

What you perceive as unsharp in an image technically has to do with the "circle of confusion," the point at which you see a defined circular shape of light in the image turn into a less distinct blur. In layman's terms, this might be understood as a "blob" of light. This blob comes from the light rays that enter the lens and strike the sensor as a cone rather than a compact point. If the diameter of the circular cone shape gets big enough, the image of that circle looks unsharp. Bokeh is an artsy name created by photographers for this blurry blob, and comes from the Japanese term for fuzzy.

Whatever you call it, those unsharp areas can create a painterly background within any image, using light to produce an aesthetically pleasing wash of color and indistinct form. To produce these types of backgrounds, get fairly close to the subject and use a long focal length at a wide aperture. Having a high key (mostly light tones) subject helps, because a dark background or subject might obscure the bokeh. It is also said that the more diaphragm blades you have in the lens, the more optimal the bokeh effect, with nine being considered the ultimate in bokeh producing lenses, but don't let that stop you from using this technique with any lens you own.

*Exposure Mode:* Aperture Priority
*Aperture:* f/4
*Shutter Speed:* 1/1000 second
*ISO:* 200
*Metering:* Center-weighted
*White Balance:* Daylight
*Focal Length:* 140mm

**did u know?**
Very out of focus backgrounds can be used to obscure all detail information and create large "circles of confusion." These become painterly backdrops that can be a lovely context for an isolated subject, like this magnolia blossom.

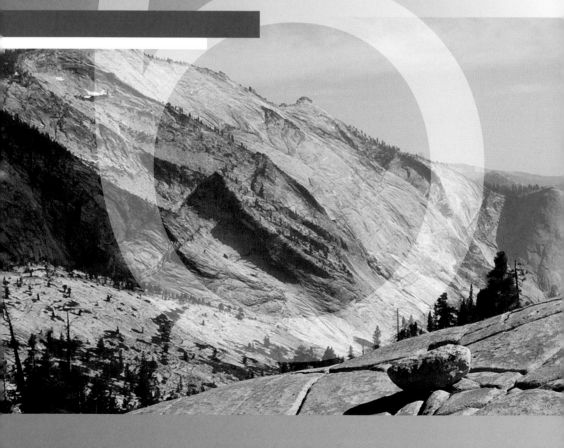

# The Digital Advantage

6

**T**here is almost a duality when we consider today's cameras: First is the photographic element, which shares features and functions among all cameras, including film-based models; and there is the digital side, where the functions and operations are available exclusively through digital technology.

Many of the topics covered in this book might be applied to all cameras and photographs. However, in this section I'll address some of the features that are solely benefits of microprocessors and the digital image file. Many of these functions can be performed in the camera, where more and more photographic processes are being incorporated. Others can be applied later in the workflow using computer software, where image processing opens up a whole new world of creativity and customization of the image.

I'll also cover one problem that is not a benefit of new technology— dust. This section only scratches the surface of how digital images can lead to new and exciting ways to make photographs. But hopefully it will help you discover the potential within each image.

# 6.1 Increase Dynamic Range
## to Increase Your Image's Appeal

## Tools:

- Tripod
- Autobracketing (AEB)
- Shutter priority mode
- Spot metering
- Continuous shooting mode
- HDR software: Adobe Photoshop, Photomatix Pro

extract details in the highlights (from normal or underexposed scenes) and the shadows (from normal or overexposed scenes), and put them together in one frame. The technique is called HDR (high dynamic range). In some ways it is the visual equivalent of suddenly hearing surroundsound after being used to monaural audio recordings.

**The sensor in your camera can** record a certain range of brightness levels from light to dark (contrast). This is called the sensor's dynamic range, which can vary from camera model to camera model. When the contrast is too high for your sensor to record detail in the light areas, you can set the camera to properly expose for the highlights. But the corresponding result from biasing exposure towards the highlights is that shadow areas become darker and lose detail.

However, digital imaging provides a way to expand the sensor's normal contrast and get a more realistic (to the eye) photo. This is done by recording multiple image files of the same scene using different exposure values, then using software to combine those files to

There are numerous methods used to combine two or more differently exposed images of a scene into a single frame. You can make each image a Layer and then use a Layer Mask in your image-processing program to cut out portions of one layer to reveal selective areas of the other frame(s). Or you can use software that is specifically designed to combine the exposures for you. The special software does this by mapping brightness values using histograms and, in essence, using that tonal data to stitch the multiple exposures into a single image with a fuller dynamic range. Increasingly, cameras are doing this with on-board software as well, although the level of nuance and sophistication is somewhat less than the results when using computer applications.

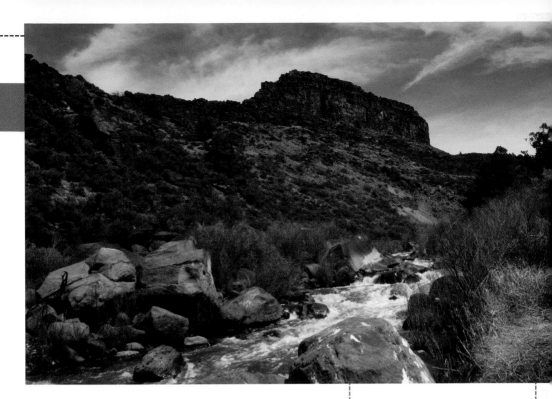

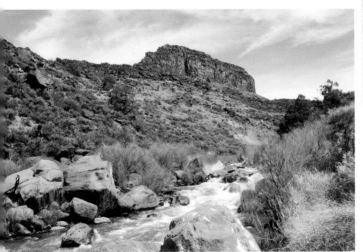

*Exposure Mode:* Aperture Priority
*Aperture:* f/11
*Shutter Speed:* 1/250 second
*ISO:* 100
*Metering:* Spot
*White Balance:* Auto

The photo used as your "base" is the most important. It should be underexposed to the point where highlight areas are fully saturated, with no warning blinkies.

*Exposure Mode:* Aperture Priority
*Aperture:* f/11
*Shutter Speed:* 1/60 second
   (arrived at via auto exposure bracketing)
*ISO:* 100
*Metering:* Spot
*White Balance:* Auto

One or more of the photos in your bracketed series should be overexposed enough to reveal full details in the darker, shadow portions of the scene.

The final HDR image follows on the next page.

In order to use an HDR technique, you need to bracket, meaning you make several different exposures of the same framing. You can bracket automatically (AEB) or manually. Make sure at least one of the bracketed photos is exposed so that no blinkies are evident when the highlight warning is displayed (see section 4.3). You can do this by pointing your spot meter at a highlight area and applying a slight amount of plus exposure compensation. This insures that highlights are properly exposed, and will cause the rest of the image to look quite dark. The rest of the bracketed series should be overexposed enough to insure that there is detail in the shadow areas, even if that washes out highlight detail.

The number of shots in a sequence varies from three to five and more. Most cameras have three shots in their autobracketing sequence, but you can make as many as you like using Manual exposure mode and changing aperture and/or shutter speed yourself. It is easiest to reproduce the exact scene (and keep your camera steady) by mounting it on a tripod, although some folks shoot at a very fast framing rate and shutter speed and handhold it throughout, using software to make sure the multiple images align properly.

**did u know?**

Keep a constant aperture by shooting your bracketing sequence in Aperture Priority mode. This will change shutter speed values to produce the bracketed images.

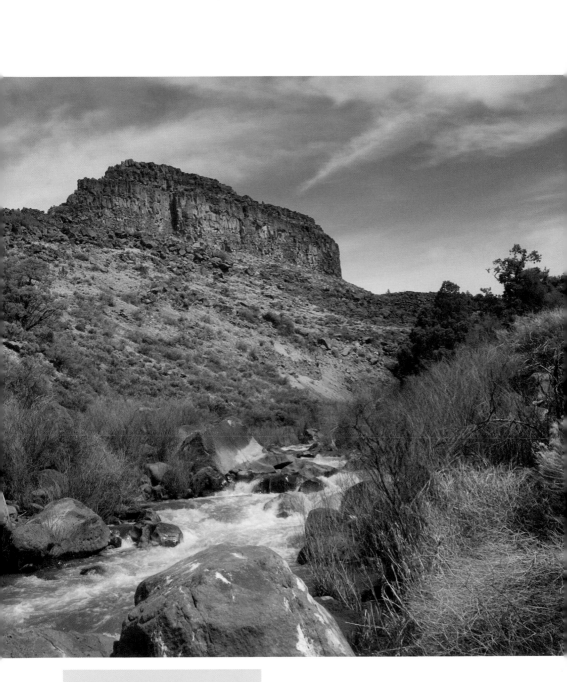

The final stage is to merge a few of the images—as little as two and as many as five or more. Here's the image with increased dynamic range (+2EV) that results from merging the previous two photos in Photomatix Pro software.

# 6.2 Improving Results
## with Live View

## Tools:

- Live View mode (for cameras with this feature)
- White balance
- Monochrome mode
- Monochrome filters
- Manual exposure mode

**The thought of reducing** a highly automated instrument, such as your digital camera, to mostly manual operation may seem odd. But doing so, especially if your camera has Live View, can give you more control over your photography. You may also find improved exposure, focus, and even compositions. (This assumes, of course, that the LCD is not obscured by light reflecting off its surface. Of course, always switch to the eyepiece viewfinder if you can't see what you are shooting.)

*Exposure Mode:* Manual
*Aperture:* f/5.6
*Shutter Speed:* 1/60 second
*ISO:* 100
*Metering:* Center-weighted Averaging
*White Balance:* Shade

Live View enabled me to check out the effect of exposure changes prior to making the shot. Using Manual exposure mode, I quickly made two choices, one brighter (left) and one darker (right). I was able to see the changes on the LCD as I changed the shutter speed setting.

With your camera set for Live View, the advantages of working in Manual exposure and Manual focusing modes are numerous. First, most Live View screens are reactive to you settings, meaning you can preview the effects that features such as white balance and filters will have on the image, as well as your focus and exposure choices. Though screen exposure may not be 100% accurate, you will soon get a very good feel for how the LCD image echoes the actual success or failure of the exposure settings. This works best when the camera is locked on a tripod, as moving the camera even slightly can change the exposure readings.

*Exposure Mode:* Manual
*Aperture:* f/5.6
*Shutter Speed:* 1/200 second
*ISO:* 100
*Metering:* Center-weighted Averaging
*White Balance:* Shade

I magnified the image on the LCD in Live View prior to this photo so I could critically examine sharpness in the petals of the upper flower. It's like putting a loupe over the LCD. I was also able to preview my white balance setting, and changed to get just the color I wanted without having to post-process in the computer.

*Exposure Mode:* Aperture Priority
*Aperture:* f/5.6
*Shutter Speed:* 1/500 second
*ISO:* 200
*Metering:* Center-weighted Averaging
*White Balance:* Daylight
Manual focus

*Exposure Mode:* Aperture Priority
*Aperture:* f/5.6
*Shutter Speed:* 1/500 second
*ISO:* 200
*Metering:* Center-weighted Averaging
*White Balance:* Shade
Manual focus

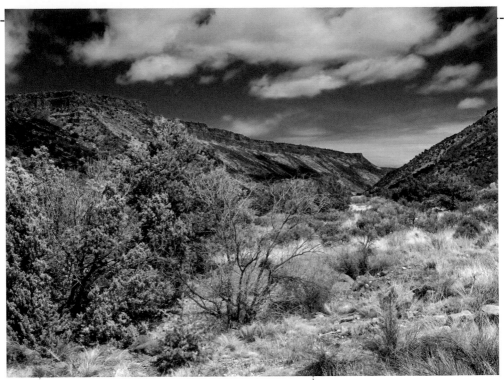

*Exposure Mode:* Aperture Priority
*Aperture:* f/8
*Shutter Speed:* 1/500
*ISO:* 100
*Metering:* Center-weighted Averaging
*White Balance:* Auto

Likewise, you can use Live View with Manual focus to magnify certain areas of the frame to help with critical focusing, a feature that is invaluable for close-up work. Of course, working on a tripod is the best way to go about this type of photography.

Live View has also produced an exciting change in black and white photography, because many photographers have difficulty previsualizing a scene in monochrome. Now, as emulated with a red filter effect in the top photo above, this feature allows you to switch on the Monochrome mode and see the scene in black and white before you shoot. (See Section 2.5 about adding in-camera filter effects).

# 6.3 There Are Ways to Deal
## with Digital Noise

*Exposure Mode:* Aperture Priority
*Aperture:* f/11
*Shutter Speed:* 1/125
*ISO:* 800
*Metering:* Center-weighted Averaging
*White Balance:* Auto
Noise reductions simulated to reflect
   in-camera settings

## Tools:

- Noise reduction function (in-camera menu)
- Noise reduction software for computer

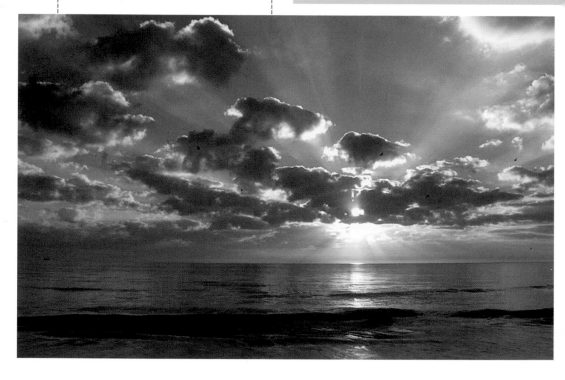

**Unlike grain, which could be used** as an aesthetic element in a film image and print, digital noise shows up as unwanted artifacts or specks of discontinuous color and tone in some of your digital images. It is rarely attractive. While some might argue that noise yields an impressionistic look, there are better ways to do that using plug-in filters and special effects software that are more controllable and pleasing to the eye.

The sky in this sunrise scene seems fine when viewed at normal size in the LCD (left, at default NR), but in reality shows coarse noise and artifacts when enlarged (below).

Generally, noise occurs as a result of several different circumstances: When long exposures are used (most commonly when the shutter speed is greater than one second); with high ISO settings, because of the increase in gain (electrical current in the sensor field used to increase light sensitivity); or, sometimes in large areas of continuous tone, regardless of the shutter speed or ISO settings. It can even be generated when working in very warm temperatures.

In terms of eliminating noise, it is always preferable to shoot with enough light to avoid long exposures and high ISO settings. But in-camera NR (noise reduction filtration) can be handy when you are intentionally recording low light photos, especially without a tripod, or in other circumstances when raising ISO solves a field problem. NR does filter noise, but it does so by smoothing images, which makes them less sharp. How much smoothing an image can take will depend on subject matter and detail within the scene.

The microprocessor in a digital camera will attempt to filter out noise automatically during processing, the extent of which depends on the exposure and ISO setting. In addition, many models also allow you to increase or decrease noise reduction levels (usually referred to as NR in menus), which you may choose to do depending on the current lighting conditions. However, you may not always be sure how much noise reduction you need to apply.

To eliminate the guesswork, experiment with all of the various levels of noise reduction at high ISO settings (ISO 800 or higher). Choices are usually something like Off, Low, Normal, High, or Extra High. To judge if smoothing is tolerable or whether it interferes too much with the sharpness, enlarge sections of before and after images on the LCD in playback and compare results.

The middle level of NR (top) helps remove the most egregious noise, while the highest level nearly eliminates the noise altogether (bottom). But it also blurs the flying bird and yields an almost synthetic smoothness to the image tones. Even if the highest setting worked well for this image, it certainly would not be practical for a scene with more details.

The final choice for me was a level of noise reduction that helped smooth the noise out without unduly softening the image.

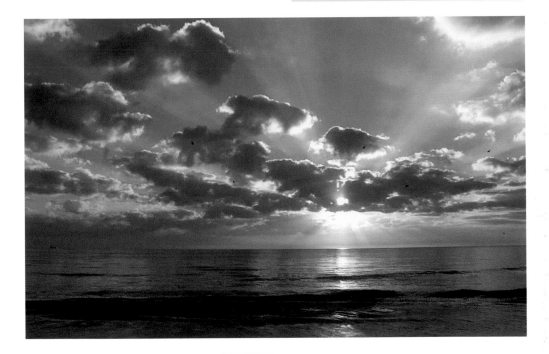

## did u know?

There are very good software solutions for your computer that allow a fine degree of NR control, helping you walk the line between excessive smoothing and a tolerable level of noise elimination. You might want to invest in such a program if you often shoot using high ISO settings, or find that noise is generated because of the type of images you like to make. However, don't stop experimenting with in-camera NR, because a combination of moderate in-camera and additional computer NR is often the best solution.

# 6.4 Show the Grandeur
## of Nature with Panoramic Images

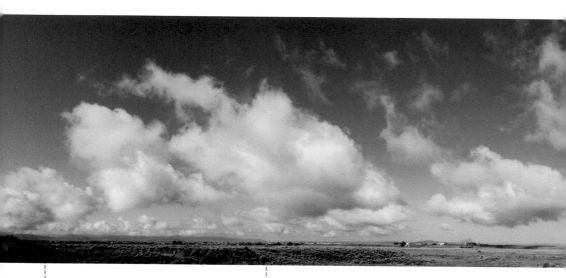

*Exposure Mode:* Manual
*Aperture:* f/11
*Shutter Speed:* 1/250 second
*ISO:* 100
*Metering:* Center-weighted Averaging
*White Balance:* Auto
  Seven separate images overlapped and
  created as panorama using Pho
  tomerge tool (Photoshop)

## Tools:

- Manual exposure mode
- Tripod with panning head
- PhotoMerge in Photoshop, or similar panorama stitching software

**There are numerous programs that** place photos together, combining several shots end-to-end (or top-to-bottom) to create a panoramic (wide view) image. Each program relies on a set of separate pictures, often three or more, that can be seamlessly arranged in sequence, showing neither discontinuity of exposure nor lapses in content. In order to achieve the required consistency in exposure and content, it is important to use Manual exposure mode and to make sure the images overlap sufficiently to allow the program to do its job.

Why Manual exposure mode? Because Manual mode insures that the camera does not change aperture of shutter speed settings from shot to shot with the series. Any of the automatic exposure modes will alter exposure in reaction to the changing light as you shoot across the scene, leading to potential variation from one image to the next in terms of color and tone. This is one of the chief causes of poor blends, especially when shooting sky.

Stitching software is quite sophisticated. The full panorama in this example is a blended composite of seven separate images. Photoshop's PhotoMerge tool creates a separate layer for each exposure (left). If you turn off one of the layers (above), you can see just how sophisticated the stitching process is.

When getting ready to record a panoramic photo, make a test exposure to see if the highlights are under control, and adjust settings as necessary. Then record your series of images. To make sure the software program will have enough information to successfully merge the images, you should overlap portions of the frame from one shot to the next by at least 30%. Don't be "cheap" with the real estate in this respect, as the software will show some breaks in continuity if you are.

*Exposure Mode:* Manual mode
*Aperture:* f/11
*Shutter Speed:* 1/250 second
*ISO:* 200
*Metering:* Center-weighted Averaging
*White Balance:* Auto
Four separate images recorded with
  300mm focal length, overlapped and
  created as panorama using Photoshop
  PhotoMerge software.

**did u know?**

Panoramic images are one of the very best ways to express wide-open spaces with any lens. You can even use a telephoto lens to get closer to distant subjects, where the angle of view would ordinarily be quite narrow and limited to one section of the landscape. But you can expand the view, in this instance to capture the full expanse and drama of this amazing sky, by using a stitching technique. This tele/wide point of view is unique to panoramic techniques.

Use a horizon line to help keep the camera level if you are not shooting on a panning tripod head. Keep in mind that you are trying to maintain a steady alignment from shot to shot across a horizontal axis, and divergence will result in wasted image space that must be lost in cropping later.

# 6.5 Don't Let Dust
## Spoil Your Pictures

## Tools:

- **Prevention**
- **Cameras with automated dust removal systems**
- **Image-processing tools (cloning, blurring, etc) to remove spots from image file**

Who knew that digital sensors would be magnets for dust? But they are—acting like little static electricity machines that attract small dust particles that are a pain in the neck, showing up as unappealing blotches, dark spots, and streaks. It is possible to remove these blemishes (spot them) using cloning tools and various brush and blur tools found in image-processing programs, but the frustration of having to spot images is not a good use of time, especially when the problem can be eliminated or diminished with a bit of care.

Dust is pernicious and can work its way inside the camera in more ways than one. Many cameras now incorporate dust cleaning systems that generally vibrate the sensor to shake the dust off; sometimes this works, and other times you might have to use more drastic measures. Other cameras use a proprietary software system that determines where dust is appearing in your photo files and spots the photos automatically. The best bet is to prevent dust from catching on the sensor in the first place. Here are some steps to help reduce dust accumulation:

1. **Always store the camera in a case or bag. Otherwise, you are needlessly exposing it to ambient dust.**

2. **Never change a lens with the D-SLR turned on. Having a charge across the sensor plane attracts dust.**

3. **If possible, change lenses inside a vehicle or changing bag, especially if there is any wind. This is where most dust problems occur. Merely shielding the lens change with your body does not usually help.**

4. **When shopping for a camera, get one with a dust reduction (shake) system, and one that bills itself as having extra seals to prevent dust.**

Tip

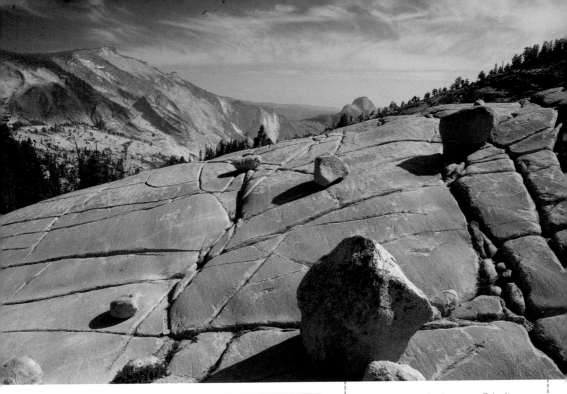

At first look, the original shot (above) looks OK. But close inspection reveals the dust nightmare it contains (immediately below). Dust has been a common problem with D-SLRs, which is why you should use precautions to reduce it and consider using a camera with a dust cleaning system. If all else fails, you can spot the unwanted faults, removing them with image processing tools (bottom).

*Exposure Mode:* Aperture Priority
*Aperture:* f/22
*Shutter Speed:* 1/80
*ISO: 100*
*Metering:* Multi-segment (Evaluative/Pattern)
*White Balance:* Daylight